'HOW TO'

BOOK OF
PHOTOGRAPHY
PICTURE TAKING & MAKING
DAVID STRICKLAND

BROCKHAMPTON PRESS

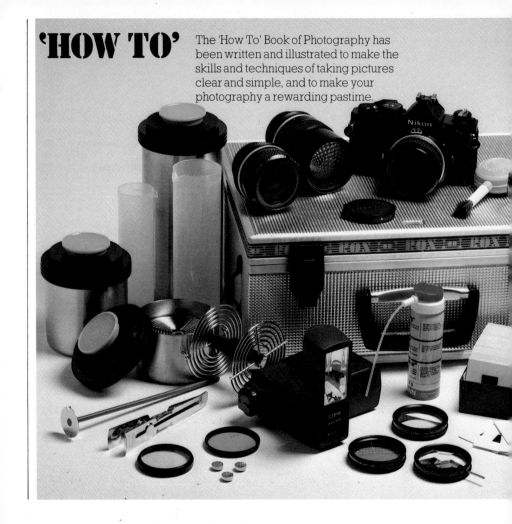

'HOW TO'

The 'How To' Book of Photography has been written and illustrated to make the skills and techniques of taking pictures clear and simple, and to make your photography a rewarding pastime.

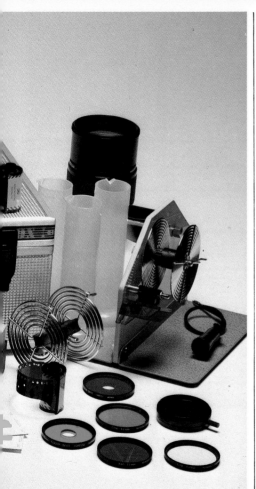

Contents

The 'How To'Book of Photography
was conceived, edited and designed by
Simon Jennings and Company Limited

This edition published 1996 by
Brockhampton Press Ltd,
20 Bloomsbury Street,
London WC1B 3QA

Text and illustrations
© 1981 Simon Jennings & Co Ltd

ISBN 1 86019 229 7

Printed and bound in U.A.E.

THE AUTHOR
David Strickland is a
photographer and
graphic designer working
mostly in the field of
publishing. He is also a
lecturer in these
disciplines in the
Department of Visual
Communication at
Brighton Polytechnic.
He learned photography
by working in commercial
studios, first as a
darkroom assistant and
then as a junior
photographer. During
the 1960's, as a
designer/photographer
for the Pirelli group, he
worked with many of the
leading photographers of
the period.

Introduction

This book sets out to show you more than just the 'how to' of photography, it gives the 'why', the 'where' and the 'when'.

Any camera, no matter how sophisticated, is a box with a lens positioned opposite a piece of light sensitive material – a device to render the real world into two dimensions. Little skill is required to point a camera and take a picture, but to produce good photographs, consistently, you have to consider and cope with many other factors. The choice of camera, lens and film, time of day and quality of light, camera position and that all-important moment of exposure – these are some of the technical elements which will confront you.

The qualities of imagination, perception and inventiveness are the creative elements that will give your pictures individuality. Also, an ability to handle your equipment with confidence so that you can be ready to take a picture almost before it happens.

Composition is another factor that needs consideration. The relationship of elements within the picture to each other, and to the background, and the positioning of a specific part of the picture to give it emphasis are just some of the important aspects of composition. Analysing the pictorial elements of a scene, and studying your own and others' photographs, will help your understanding of composition.

Photography is used as a recording medium in science, industry, medicine and in almost every activity that man is involved with. In most cases, the pictures are required to have little or no aesthetic value and will command little emotional response, but it is the latter that most great photographers are trying to elicit with their work.

This book has been designed to help you form a better understanding of the nature of photography. We take a simple approach to cameras, lighting (both artificial and natural), developing and printing; we show how to get the best out of a subject and how to do so with the simplest of equipment. We recommend a basic kit of camera and accessories *(see page 33)* which will enable you to tackle quite a wide range of photography. Above all, we hope that this book will help you to a greater understanding and perception of the visual world and, by so doing, help you become a better photographer.

What is photography?

Light is the essence of photography; the word 'photography' means 'writing with light'. As a rule, most objects either reflect or transmit light rays or absorb them. Everything we see is defined by these rules and the camera works on the same principles.

The action of light on most materials causes a chemical change to take place; the tanning of human skin is an example. It is this principle that has enabled us to record permanently, in the form of a photograph, almost anything we can see.

The Greeks recorded the fact that light shining through a small hole in one wall of a darkened room projected an inverted image of the view outside onto the opposite wall. The Italians were later to name this the *camera obscura*, meaning a dark room.

In the latter part of the 16th Century the use of lenses, which made the image brighter and sharper, meant that the camera obscura could be used as a drawing aid. Portable versions were eventually produced and were much used by landscape and portrait painters. It was not until the 19th Century, however, that ways were found to record the image.

The pioneers

The camera obscura, *below*, was invented over 2000 years ago, but real progress was not made until the 19th century. The first colour picture was made by James Clerk Maxwell in 1861, *right*, and autochromes, *left*, were popular by the turn of the century. The Kodak No.3 of 1901, *far right*, instigated a design which remained in use for over 50 years.

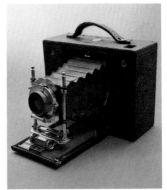

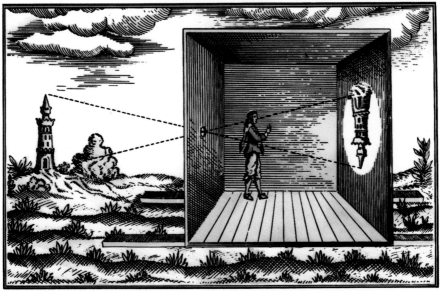

The basic history

In 1802, Thomas Wedgwood and his friend Humphrey Davy, found that the action of daylight on certain chemical salts enabled them to produce a photographic image. They coated white leather or paper with a solution of silver nitrate and exposed it to daylight with leaves and other objects placed upon it. The material darkened in the light but left a silhouette of the objects. Unfortunately, they had not yet found a way to fix the image and soon the material became dark all over.

It was Joseph Nicéphore Niépce who, in 1826, produced the first permanent photographic image. He coated a pewter plate with a solution of bitumen of Judea in oil of lavender. He exposed the plate for eight hours during which time the sunlight hardened the coating. The plate was then washed to remove the soft unexposed areas and a positive image remained.

Niépce later went into partnership with a more enterprising Frenchman called Louis Daguerre. He improved on Niépce's method by a mercury vapour development, which cut exposure times down to twenty minutes and made it possible to take photographic portraits. In 1839, Daguerre published the details of the process, calling it the Daguerreotype. The demand for portraits was soon world-wide.

At the same time, in England, William Fox-Talbot was conducting experiments based on Wedgwood's work. He found a way to fix the negative image on paper and then, by contacting to another surface, he was able to produce a positive print. His photographs did not have the clarity of the Daguerreotype but he was able to produce more than one print from the original negative.

The next step came after Daguerre's death in 1851. A British artist and photographer invented the wet plate process. This process improved the picture quality and greatly reduced exposure times. The only problem was that the plate had to be exposed wet and processed before it had time to dry, but the process was immediately adopted by most photographers in preference to the Daguerreotype.

By the late 1870's George Eastman had perfected a dry plate process. Eastman soon found a way to put his coating on to a flexible base and this led to the introduction of the first Kodak box camera, the No. 1, in 1888.

The modern camera

The modern camera consists of a lens, a diaphragm, a shutter and a mechanism to hold and transport the film.

The diaphragm is an adjustable aperture, usually incorporated in the lens; it can be opened or closed according to the available light. In bright light, it can be closed or 'stopped down' to reduce the amount of light reaching the film and it can be opened up in poor light to allow more light to reach the film. The diaphragm is calibrated in stops or 'f' numbers.

The shutter controls how long the light will be allowed to pass through the diaphragm on to the film. Together, the diaphragm and the shutter will control the exposure of the film. There are two main types of shutter: a diaphragm shutter set in the lens and used in viewfinder cameras, and a focal plane shutter, which works like a roller blind and is set just in front of the film – used in single lens reflex cameras.

The camera will have a film wind-on and most will cock the shutter automatically to avoid double exposure. The exceptions are the older cameras, and the plate types used by professionals. All cameras have some sort of viewing system, and the better SLR cameras have built-in exposure meters.

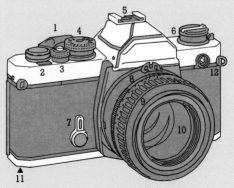

The modern camera
The camera recommended in this book is of the 35mm single lens reflex (SLR) type. It has adjustable focus and aperture and should have a built-in (through-the-lens) light meter. It also has interchangeable lenses and a hot shoe attachment on which to clip a synchronised flash unit.

See also page 16

Basic components
1 Film advance lever
2 Exposure counter
3 Shutter release
4 Film speed dial and shutter setting
5 Hot shoe
6 Film rewind lever
7 Self timer lever
8 Aperture control ring
9 Focus control ring
10 Lens
11 Film release button
12 Clips for carrying strap

People & animals

People and animals seem to be the two subjects that both the photographer and the viewer like the most – whether it is a kitten playing with a ball of string or a group of workers having an argument. In attempting to capture, and appeal to, human responses and emotions, the photographer is facing a difficult task. People, and animals for that matter, need to be approached with both confidence and sensitivity if good results are to be achieved. The photographer will need to operate his camera with the minimum of fuss, be able to change lenses and take light readings without drawing too much attention to himself. He will, in fact, have to learn how to 'disappear'.

● See also pages 44-53

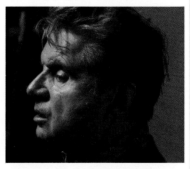

Portraits *(left)*
Portraits need not be stiffly formal. None of these pictures is heavily posed: the top one achieves some spontaneity – with the help of a bribe! The middle portrait achieves an interesting effect using natural light, while the bottom picture makes good use of an unexpected element and an unusual angle.

Groups *(right)*
These pictures show the range of formality which can be used in group shots. The top picture is entirely informal – a 'found' group. The middle picture has been arranged, but loosely, to make a relaxed group. The bottom one, by contrast, has been carefully contrived.

Animals *(far right)*
These pictures show two elements of animal photography: the spontaneity of people and animals together, and the formality of the animal study. In the latter, you may have to contend with unexpected movement, especially if you are working at close quarters.

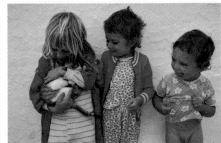
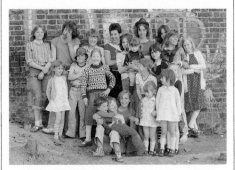
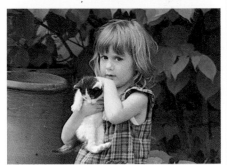
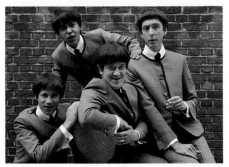
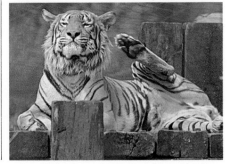

11

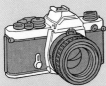
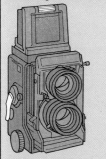
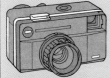

Choosing your camera

The most important consideration when choosing a camera is what you are likely to use it for. What kind of pictures do you intend to take? If you are just beginning with photography, and you have no idea in which direction you are going, it will be best to start with a camera that is as adaptable as possible. Choose a system that allows you to build from a simple start but will still be useful once you have all the equipment you need.

For the serious beginner, a 35mm camera that has the facility for interchangeable lenses is probably the best buy. You will find that there is a wide range of equipment at all prices. With a 35mm camera you get ease of handling and carrying and the availability of a large selection of films and accessories.

Viewfinder cameras

This is a camera that has its viewfinder separate from the lens but built into the camera body. All the popular cartridge type cameras use this system.

In the cheaper versions, you will find a discrepancy between what you see and what the camera takes. This is known as the *parallax* error, and the closer the subject gets to the camera the worse it becomes. It is best over-

come by positioning your subject to the bottom of the viewfinder. The viewfinder image will be larger in area than the final picture and a bright line frame shows the true extent of the picture area in the viewer.

The *parallax* error does not occur in the better cameras with coupled rangefinders for focusing. On this type the rangefinder gives a double image, one being slightly ghosted, and by rotating the focusing barrel on the lens the two images can be aligned to any chosen point. This will give correct focus on that point. On the cheaper cameras, the lenses are of the *fixed focus* type, *limited focus* (near, medium and infinity) or *preset focus.*

Some rangefinder cameras have the facility for interchangeable lenses but the range of lenses is limited unless you fit additional viewfinders for each one.

The great advantage of these cameras, however, is that they are quieter and lighter than SLRs. The relative absence of shutter noise ensures that rangefinder cameras are much used by professionals, especially in theatres, film studios etc., where distractions must be avoided.

See pages 16/17 32/3

VIEWFINDER/RANGEFINDER

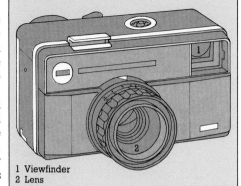

1 Viewfinder
2 Lens

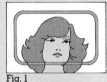

Fig. 1

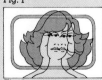

Fig. 2

Fig. 3

In most of the cheaper cameras, such as the 'Instamatic' cartridge type shown above, the viewfinder is separate from the lens. With this arrangement it is necessary to compensate for parallax error. Position the subject low in the viewfinder to avoid this (**fig. 1**). On more sophisticated rangefinder cameras, you will see a double image of the subject through the viewfinder (**fig. 2**). Align the two images for correct focus (**fig. 3**).

Photographing action

In shooting action pictures, you have to learn to use your camera quickly and have it ready at all times. Be prepared to shoot a lot of film to get the right picture. But the real problem with action photography is to be in the right place at the right time. This is not always so difficult as it sounds: many activities, especially sporting events, follow a regular pattern which enables you to prejudge position and direction. Whether you are stopping the action by 'panning' the camera, or creating a sense of movement by allowing the subject to travel across or towards the lens, action photography seldom offers a second chance if things go wrong. It is vital to be alert and ready.

● See also pages 54-59

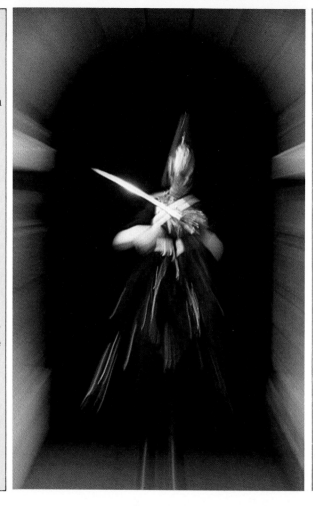

Creating action *(left)*
Dynamic effects of speed and movement can be created where none exist. For this you must use a zoom lens. Having focused on your subject, alter the length of the zoom during exposure.

Panning *(top)*
By following a moving subject with the camera and taking the picture as the subject passes in front of you, an impression of speed is created. The moving subject will be sharp against a blurred background.
Obviously, the degree of blur will be related to the speed at which you have to move the camera.

Freezing action *(bottom)*
People and objects moving at speed can be 'stopped' in mid action by using high shutter speeds – as these two pictures demonstrate. The important thing, in all action photography, is to decide what effect you want to create and which technique is most likely to achieve it. You will have little opportunity to change your mind during fast moving events.

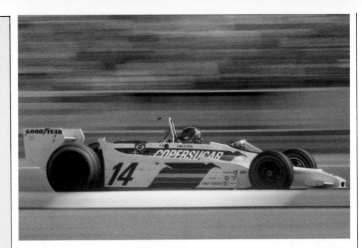

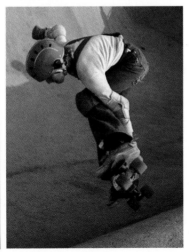

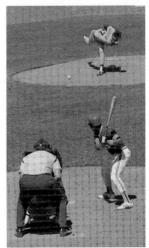

15

Choosing your camera

The single lens reflex

There is no doubt that the SLR has become the favourite system with both amateurs and professionals. The wide range of lenses and accessories make it almost unbeatable. The 35mm versions can offer high quality results and a fairly inexpensive range of subsidiary equipment for printing and projection.

The image comes through the lens via a mirror and a pentaprism and is viewed on a ground glass screen. It will be identical to the image on the film. A spring mechanism links the mirror to the shutter release, so that when the shutter is tripped the mirror automatically snaps out of the way. The absence of parallax error ensures that you can accurately compose your picture, even in situations where close foreground subjects may form part of the composition. With viewfinder cameras the distortion means that you do not see a true relationship between foreground and more distant objects.

The larger format SLR's work on the same principle, using 120 or 220 film size, giving either 6 cm (2¼ ins.) square or 6 cm x 7 cm (2¼ x 2¾ ins.) negative size. These cameras are much more expensive and are bulky in use.

THE SINGLE LENS REFLEX

The unique feature of the single lens reflex camera is a mirror which reflects the image on to a viewing screen until momentarily before exposure.
In **fig. 1** the mirror is down and reflecting the image upwards to a ground glass viewing screen. This image is transferred to the eye via a pentaprism.
As the shutter release is pressed **fig. 2**, the diaphragm closes down to the chosen aperture and the mirror flips up, obscuring the viewing screen but allowing light onto the film.
In **fig. 3**, the mirror is returning to its original position immediately after exposure.

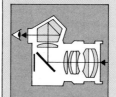

fig. 1

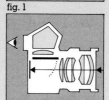

fig. 2

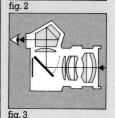

fig. 3

35mm film

This comes in cassettes with either 20 or 36 exposures on one film. Cassettes are easy to load into the camera.

See also pages 12-13, 32-33

The twin lens reflex

This camera has one lens mounted above the other about 3 cm (1 in.) apart. The top lens is for viewing and the lower lens, which incorporates the shutter and diaphragm, takes the pictures. Nearly all types use 120 film and give 6 cm (2¼ ins.) square pictures. The main disadvantage with this system is the lack of interchangeable lenses, although there is one twin-lens camera with this facility. In general, though, these cameras are considered to give a good quality result.

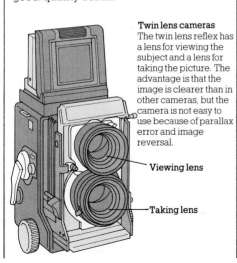

Twin lens cameras
The twin lens reflex has a lens for viewing the subject and a lens for taking the picture. The advantage is that the image is clearer than in other cameras, but the camera is not easy to use because of parallax error and image reversal.

Viewing lens

Taking lens

Instant picture cameras

Invented by Dr. Edwin Land in 1947, the instant picture process gives a finished and permanent print a few seconds after exposure. No darkroom is required and the only material cost is the film. There are two types of camera in use: in one, the film is removed from the camera after exposure and peeled apart after the required developing time. In the other, more modern, process a white plastic card is automatically issued from the camera. On this, the picture gradually appears – reaching full density in 5-10 minutes.

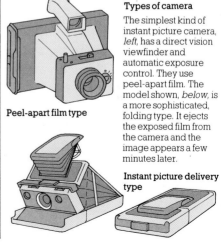

Types of camera

The simplest kind of instant picture camera, *left,* has a direct vision viewfinder and automatic exposure control. They use peel-apart film. The model shown, *below,* is a more sophisticated, folding type. It ejects the exposed film from the camera and the image appears a few minutes later.

Peel-apart film type

Instant picture delivery type

Photographing landscapes

The variations in light, time of day, weather and the seasons make it possible to photograph the same scene for a lifetime without taking the same picture twice. Unfortunately, landscape photographs can be very dull, usually because the photographer tries to capture the sheer size of the landscape by including everything he sees in the picture. It is better to select an area that may be typical of the overall landscape and by careful composition create a feeling of space. The positioning of foreground objects that will lead the eye into the picture and a strong diagonal form to create perspective, will help to give the picture form and depth.

● See also pages 60-71

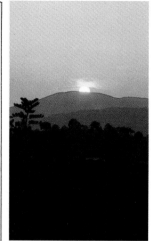

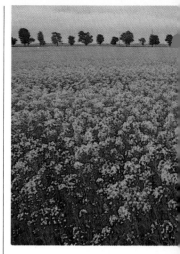

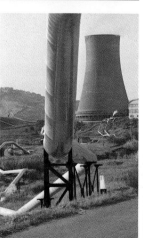

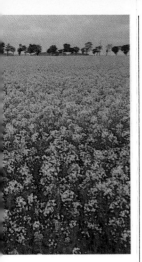

Landscapes *(left)*

Very often, the success of a landscape picture depends upon the angle of view. The photograph of the sunset was taken from a high viewpoint enabling the photographer to include foreground trees and middleground hills which help to lead the eye into the sunset. The field of rape was taken from a low angle of view with the aperture stopped down as far as possible. In this way, we see both the form and the mass of the flowers. In the other views, the pipeline and the road serve to lead the eye into the picture.

Buildings *(right)*

The urban landscape offers an abundance of subjects to the photographer. They do not have to be architectural masterpieces, even derelict buildings and shop fronts have their attractions. You will find a wide-angle lens useful for this kind of work. For details, such as the clock and the drainpipe bosses, use a telephoto lens.

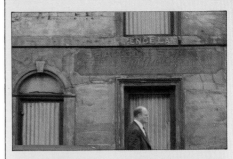

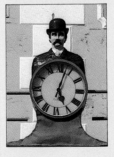

THE COMPOUND LENS

Most modern cameras, such as the 35mm SLR we recommend, are supplied with a standard lens (50 or 55mm) which gives an angle of view similar to that of the human eye. These lenses contain several elements, some converging and some diverging, in order to eliminate errors in image formation. They also have an in-built facility to change focus from near to far subjects and an 'Iris' diaphragm to control the amount of light reaching the film. This is calibrated in 'f' stops which represent aperture settings and control *depth of field* – the extent of image sharpness from foreground to background. Generally, the higher the 'f' number the greater the degree of sharpness throughout the picture. For example, at f2 the depth of field may be no more than 75cm (2ft 6in), but at f8 it will have extended to 4m (13ft).

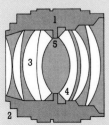

Lens basic elements
1 Lens barrel with ring controls for focus and aperture
2 Mechanism for fitting to camera
3 Converging elements
4 Diverging elements
5 Iris diaphragm

Compound lens cross-section

The lens

Basic principles
All images, whether seen by the human eye, or photographed by a camera, are formed by rays of light which are reflected by the object being viewed. The function of a camera lens is to order these light rays so that an accurate image of the subject is formed on the film.

Focal point
The light rays passing through a convex lens will bend and converge to a point which is known as the focal point. The focused image will consist of an infinite number of focal points.

Focal plane
The focal points will all lie on a line which is at right angles to the optical axis of the lens. This is called the focal plane and is the position occupied by the film in a camera.

Focal length
This, quite simply, is the distance between the lens, when focused to infinity, and the focal point. The focal length of a camera can only be altered by changing the angle at which the light bends on passing through the lens. This

can be achieved, usually, only by changing the lens. Most cameras that have the facility for interchangeable lenses are sold with a normal lens which is designed to have a focal length approximately equal to the diagonal of the picture area, 50-55 mm. This ensures that the **angle of view**, which determines the amount of the subject which can be fitted into the picture, is as close as possible to that of the human eye, i.e. about 45°.

To make the image bigger a longer focal length is necessary, to make it smaller – a shorter focal length. But changing the focal length of the lens will also alter the angle of acceptance of the camera. Therefore, a longer lens will give a narrower angle of view and a shorter one a wider angle.

Lens design

In photography, the lenses can be made of plastic or glass. Plastic lenses are used mainly for cheaper cameras and are usually of a simple construction, having only one element. The more expensive cameras will have a glass lens made up of two or more elements. This is known as a *compound* lens.

See also pages 24-5

CARE OF LENSES

Lenses, although strongly constructed, are precision engineered and need care in handling and regular maintenance. When not in use, keep them in their cases with back and front lens caps on. Keep them free from dust, sand and water.

◄ Lens caps/filters

Always replace lens caps after use. Use a Skylight IA filter as a permanent cover so that the lens never comes into contact with debris.

◄ Cleaning barrel and lens

Gently dislodge dust, grit and other dirt with a 'blower' brush which has soft bristles and an air sac to blow debris away.

◄ Cleaning glass

Remove dust with the blower brush, then wipe gently with a lint free cloth such as chamois leather. Alternatively, buy special lens cloths or tissues.

Still life photography

A still life may be found in a natural arrangement, such as a table after a meal, or it can be created by the photographer.
It can be an exercise in one of the many facets of picture making: colour, texture, line and composition – or a combination of all.
It can be interpreted as an abstract form or as a picture that tries to capture the essence of the subject. Subjects do not need to be obviously attractive, found objects often make unusual and interesting still life subjects. Indeed, almost any subject material in any location can be used as still life and will provide the photographer with a greater insight into the problems of composition and lighting.
● See also pages 72-79

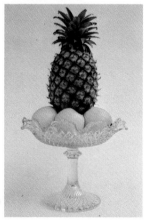

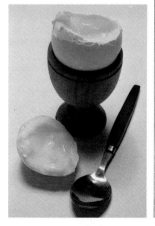

Fixed objects *(left)*
Machinery often makes impressive still life, presenting the challenge of achieving form, texture and detail all in the same shot.

Formal arrangements *(bottom left)*
The classical still life depends heavily upon composition and lighting. These two shots demonstrate that there is a beauty in simplicity and in everyday objects. But, although the arrangement is quite natural, the composition has been carefully handled.

Found arrangements *(right)*
These are the kinds of subject which are static, but variable – you must take them as you find them. The attraction here is that the composition is both deliberate and haphazard.

Textures *(far right)*
Photographing textures can be very exacting but also very satisfying. All texture pictures benefit from lighting at an acute angle.

Changing lenses

The main advantage of the interchangeable lens camera is that you can include a greater or lesser amount of your subject without changing the camera position. Pictures can be taken with wide-angle, telephoto or other specialist lenses that would be impossible with a standard lens. Lenses with longer focal length will give a shallower depth of field and appear to compress the depth of the picture. Wide-angle lenses will give a greater depth of field and an illusion of extra depth in the picture. Some distortion may occur at the edges of the picture. The illusions of greater or lesser depth which are characteristic of these lenses, can be used to good effect by the photographer – as these examples show.

A BASIC SELECTION OF LENSES FOR A 35mm SLR SYSTEM

● **Standard lens**
The standard lens, which is usually constructed from 6 or 8 elements, gives an angle of view roughly equal to that of the human eye (about 45°). Its focal length is 50–55mm.

Standard lenses 50–55mm range

● **Wide-angle lens**
This lens, while focusing as close to the film as the standard lens, will take in a much greater width of the view. Useful for big subjects at fairly close range.

Wide-angle lenses 28–35mm range

● **Telephoto lens**
These have extra diverging elements which reduce the distance between lens and image. A narrow angle of view ensures that distant objects fill the negative.

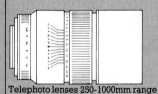

Telephoto lenses 250-1000mm range

● **Zoom lens**
Zoom lenses have variable focal lengths which means that they can be used to replace several separate lenses. Their range is not great, however, and they are heavy and expensive.

Zoom lenses 40–120mm or 70–150mm

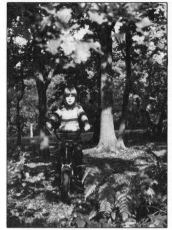
Standard lens

Wide-angle lens

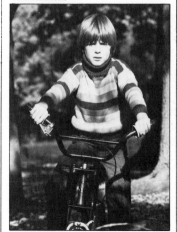
Telephoto

Zoom

Examples of different lens results

The standard lens is designed to give a result which is as near as possible to the image received by the human eye – although of a much narrower width. The wide-angle lens may take in as much as 180° of the view, and the telephoto lens will make distant objects as large as foreground objects taken with a normal lens. The zoom lens performs the functions of several other lenses and can be altered during exposure for special effects.

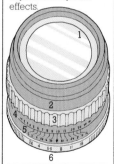

Lens operating modes

1	Filter screw thread
2	Focus reference point
3	Depth of field scale
4	Focusing distances
5	Focus ring control
6	Aperture ring control

Photographing the human form

The human figure has always been a subject of great importance to the artist, and the photographer is no exception to this. As a revelation of beauty in photography the human figure is almost exclusively shown in the female form, either clothed or naked. The female nude is a difficult subject to photograph, particularly for the amateur who may have trouble finding models, space and equipment. It may be easier to adopt a wider approach to the human form. Look for everyday actions that can reveal the grace and motion of the body: people at work and children playing offer many interesting possibilities.

● See also pages 80-83

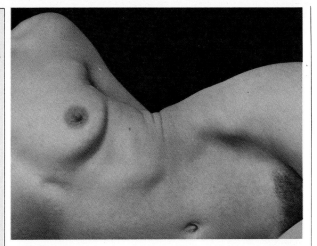

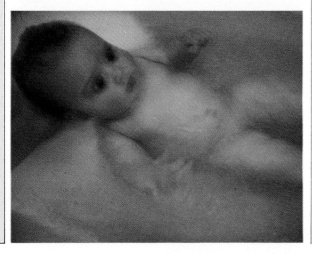

Body landscape
(top left)
By keeping the background simple, and cropping close, the human form can take on the qualities of landscape.

Mysterious quality
(bottom left)
By using a slow shutter speed and wide aperture to cope with the available light, the photographer, in this shot of a new-born baby being bathed, has created an effect which almost suggests the unborn child.

Children at play
(top right)
This graceful composition was achieved with a wide-angle lens to compensate for the lack of distance from the subject. But, in all pictures such as this, the important thing is waiting for the right moment.

People at work *(right)*
The street trader, frozen in mid transaction, succeeds in holding our attention as well as that of his customers. For this kind of shot a zoom or telephoto lens is invaluable.

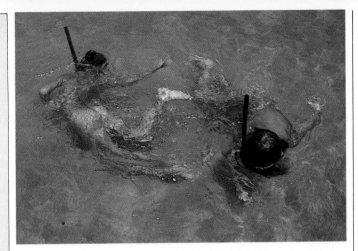

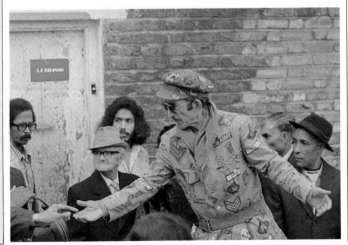

27

Black and white film

Modern black and white film works in much the same way as its 19th Century predecessors. The light is captured by microscopic crystals of silver bromide (containing small amounts of silver iodide). The crystals are carried in a transparent gelatine and together they make up an emulsion, which is coated onto a plastic base to provide support. The sensitivity of the film is determined by the size of the crystals of silver bromide. Emulsion containing large crystals needs less light to form an image than one that has smaller crystals. This means that the faster the emulsion speed the coarser the image, the finer the image the slower the emulsion speed. This will also affect the tonal range of the negative, giving a greater tonal range on a slow film and greater contrast on a fast film.

Film speed

The usual way to describe a film is by its emulsion speed or sensitivity. This is indicated by an ASA or Din number: a numerical grade of speed given to the film according to the amount of light needed to produce a normal image. Black and white film as described above is only sensitive to the shorter end of the light scale, ultra violet and green, which limits its everyday use. To make it of more practical use, dyes are added to extend its colour sensitivity to the yellow and red in the scale. The film is then known as *panchromatic* and is roughly as sensitive to colour as the human eye – although it still does not respond evenly to colour. It is still more sensitive to the short wave-length (blue).

In general use this is not a problem but if, for example, a red apple is being photographed in black and white it will remain very light on the negative and, therefore, dark on the print. When photographing a sky the opposite effect occurs and the sky may be so light on the print as to be almost non-existent. Both of these tendencies can be corrected by using filters on the camera.

There are specialist film and filters available for taking pictures in the dark which work on the invisible wave-length of infra-red. Infra-red film, working in conjunction with the appropriate filter can produce some unusual effects, such as black sky and white foliage. It is often used in aerial photography because of its ability to distinguish between dead and living vegetation.

The examples below show the effects of differing emulsion speeds. The fine grain emulsion (top) is a slower film, requiring more light to form the image, but giving much better resolution than the coarser fast film (bottom).

Slow film – fine grain

Fast film – coarse grain

Colour film

Apart from instant picture film, colour film comes in two forms: colour slide/ reversal and negative/colour print. Slides can be obtained from negatives and prints from slides. Black and white prints can be obtained from both.

Colour film is made up of three layers of emulsion, each one sensitive to one of the primary colours: blue, green and red. From these a full colour range can be produced. The film can be balanced to work in day-light or tungsten light.

Choosing colour film

There is a large selection of colour film on the market but each manufacturer or type tends to have its own particular colour balance. It is therefore up to the photographer to decide which one is preferable for his purposes. Colour film comes in varying speeds, from as low as 16 ASA up to 500 ASA, but the same rule applies to colour as to black and white – the slower the film the better the picture quality and the faster the film the coarser the quality. So, for good quality at a reasonable working speed choose the intermediate speed films: 64 ASA – 150 ASA.

Using colour

Selecting subjects

When working with colour film remember that you are working with colour itself – and colour is light. Although subject and composition will be important, they should not dominate your choice of subject. Become colour conscious and think of it as an integral part of the subject.

Creating colour effects

All colour negative material can be home processed. This gives you the scope to adjust for colour, balance and density. Most beginners send film to laboratories for processing, thereby losing control of these important factors. There are also many special and artificial effects which can be created with the camera, and it is valuable to experiment with a range of colour films and filters.

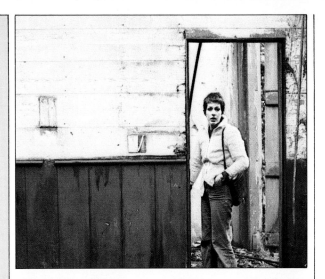

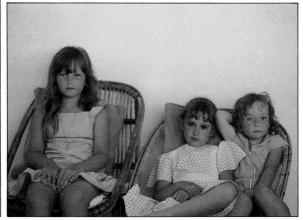

Pushed film *(top left)*
Unusual effects can be created by setting the camera to a higher rating than that of the film. This is called 'pushing'. In this example, the film was Ektachrome rated at ASA 64, but the camera was set to ASA 200. The result was a predominantly blue, high contrast photograph. The processing laboratory would need to be told that this technique had been used.

Colour filters
(bottom left)
Filters can be used to create a bias in the photograph. In this example, a yellow filter was used to intensify the dominant colours in the group. The film was processed according to the manufacturer's instructions.

Choosing subjects
(right)
Look out for subjects that will be interesting principally because of their colour. These examples were all found in the same locality. Their abstract quality ensures that colour remains the chief point of the pictures.

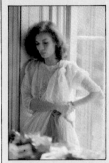

Changing use
Unusual effects can be achieved by using film in the 'wrong' conditions. The top picture was taken in artificial light using daylight film – giving an orange/yellow bias. The other picture was taken on tungsten film in natural light, resulting in a blue bias.

31

Equipment

Our choice for a beginner's kit is based on the most commonly used camera for both amateur and professional: the 35mm Single Lens Reflex (SLR). Most of the systems manufactured have a wide range of lenses and accessories which make the SLR the most versatile of cameras. As already stated, the 35mm camera body is supplied with a normal lens of 50mm or 55mm. Many photographers have found that once they have built up a system with a number of lenses, the one they use least is the normal lens. Because of this it is advisable to start your system with two lenses, if you can afford to Whether you choose the wide-angle or the zoom lens as your first alternative will depend upon your specific subject interests.

Selection of equipment
1. Storage case
2. Camera stand
3. 35mm camera with standard lens
4. Lens cleaning fluid
5. Cleaning brush
6. Zoom lens
7. Wide-angle lens
8. Computer flash unit
9. Cable release
10. Camera case
11. 35mm film cassette
12. Filters

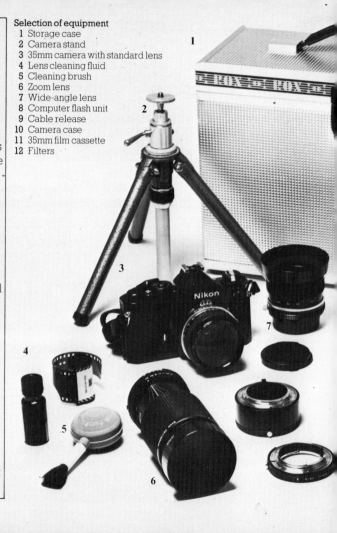

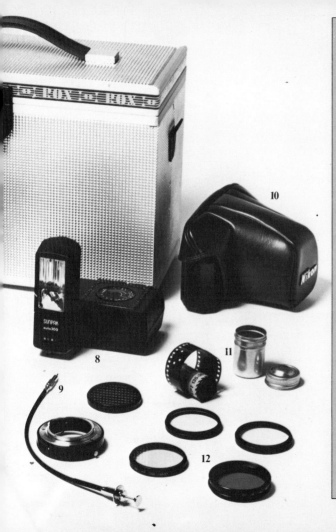

THE BASIC KIT

The Camera
A 35mm body with a built-in light meter of the through-the-lens type, complete with a carrying case and standard lens.

Additional lenses
28mm or 24mm wide-angle with lens hood.
35-140mm or 70-150mm zoom lens.

Accessories
Cable release.
Camera stand.
Close-up attachments: rings, bellows or reversing ring.
Computer flash unit.
Filters: U.V. (ultra violet), polaroid,
red and yellow.
Camera cleaning equipment.
Camera bag or equipment storage case.

HOW TO HOLD YOUR CAMERA

The design of your camera will have some influence on the way you hold it. But there are two basic methods of holding a camera: for landscape format photographs the camera is held horizontally: for portrait formats it should be turned to the vertical. With shutter speeds below ⅟₆₀ of a second support the camera on a wall or ledge – or use a stand. At speeds above ⅟₂₅₀ of a second, camera shake should not occur, but at all speeds in the middle range it is essential to hold the camera as steady as possible.

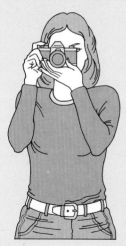

Holding position
Grip the camera firmly with one hand, leaving the index finger free to operate the shutter control. Keep the other hand free to operate the focus and aperture ring. Keep your elbows tucked in and, if you need extra support, rest the camera against your cheek. A rubber eye cap clipped to the viewfinder will provide comfortable and clear viewing.

Handling your camera

Choose a camera that you feel is comfortable and easy to handle. Make sure you can make all the necessary adjustments of focusing, changing shutter speed and aperture without removing the camera from the eye.

When taking pictures the body becomes a camera stand and certain positions are more stable than others. A basic guide is that if you feel comfortable and relaxed you should be able to operate the camera with the maximum freedom of movement and speed without the danger of camera shake or bad picture framing.

With practice, shutter speeds as low as ⅟₃₀th can be used hand held and, with the support of a wall or ground, you can expose for a number of seconds. If you do wish to use slow shutter speeds it is better to have a camera stand – this will extend the range of your photography. With the camera on a stand a cable release should be used because the camera can be shaken when the shutter release is depressed. When you are taking the picture always operate the shutter release gently, but firmly, to avoid camera shake. Never jab the shutter release.

Basic controls

The shutter and aperture control exposure, but they also have other functions. The shutter controls the degree of movement shown in the picture, the aperture controls depth of field. Depth of field concerns the nearest and furthest parts of the subject that can be rendered sharp at a given focus setting.

The selective focusing facility gives the photographer control over which part of the picture will be sharp. The aperture will extend the point of focus in front and beyond that point depending how far you stop down. For maximum depth of field, focus on a point approximately one third down the picture plane and stop down to the smallest aperture. The closer the point of focus to the camera the more restricted the depth of field. So, by selective use of focusing and aperture, subjects can be isolated to give them emphasis.

OPERATING CHECK LIST

- Make sure the camera and meter are in order.
- Load the film, making sure that it is correctly positioned on the take-up spool.
- Wind the film on to 1.
- Set the ASA (Din) rating of the film on the meter.
- When unloading first make sure the film is wound back into the cassette.

DEPTH OF FIELD

The photographs printed here provide a good visual explanation of depth of field, using the same subject photographed with different apertures.

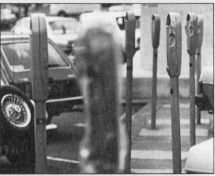

¹⁄₁₀₀₀ second at f2.8

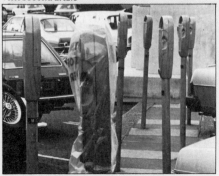

¹⁄₃₀ second at f16

COMPUTER FLASH UNITS

These are powered by batteries contained within the unit. For complete synchronisation they clip onto the hot shoe on the camera. They function automatically, so that all you have to do is set your ASA (Din) rating and aperture setting on the dial.

Clip-on computer flash unit

1 Exposure control centre with aperture and film speed scales
2 Flash window on adjustable head for 'bounce' pictures
3 On/off switch for automatic or manual control
4 Auto sensor
5 Aperture selector
6 Hot shoe connector to camera

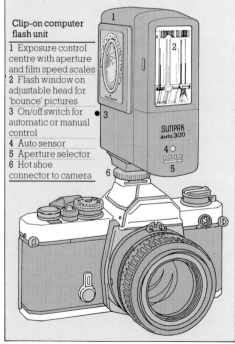

Lighting

The most useful artificial light source for the beginner is electronic flash. It provides a powerful yet versatile light source and costs almost nothing to run. But it takes considerable skill to use it well, because the light effect it gives cannot be seen until the picture is processed.

Flash units come in various types and sizes, from the large studio floor unit to the compact hot shoe type that clips onto the camera. The advantage of the clip-on units is that they are small and have their own power source, either disposable or rechargeable batteries. The light source is colour-balanced to the colour temperature as daylight colour film, which means you can use the flash with daylight, if you wish, when shooting colour.

The speed of the flash is faster than any of the shutter speeds on the camera, which means that flash is the ideal way to stop movement in photography. It also means that, when using flash, the shutter speeds are of no use to control exposure. The exposure for flash is controlled by the distance of the flash from the subject and by aperture and film speed. The exposure is calculated by dividing the film speed guide

number (this is not the ASA rating) into the flash to subject distance, i.e. film-guide no. 96 divided by subject-to-flash distance of 24 feet gives f4. The latest type of flash units have a built-in self-adjusting system and all you need to do is set the ASA speed and aperture – they are called computer flash.

Complex cameras have two settings for flash and it is important that the camera is set to the correct one, (otherwise the picture may be only partly exposed or blank). This is known as the synchronization. Settings are indicated on the camera in a number of ways, either as certain shutter speeds or as two separate connections for the synchronization lead, which are marked 'X' or 'M'. The 'X' is for electronic flash and will fire the flash the moment the shutter is fully open, and the 'M' is for flash bulbs and allows the bulbs to burn for milliseconds before the shutter opens.

The main disadvantage of flash is that it is very harsh and will give strong shadows. Also, because distance is an exposure factor, if flash is the main light source the background can be under-exposed and the foreground over-exposed – a common fault with flash.

The new flash units have the facility to swivel the head to bounce the light, giving an indirect light which is much softer and more like natural light. If the flash is bounced, adjustment must be made to the exposure because the light has further to travel. Open the aperture by two stops from the direct light calculated stop.

Flash can be used to lighten shadows when shooting against a strong backlight, but be careful not to over-light the shadows and make the picture look unreal. You can also use it a number of times in a large dark interior by setting the camera on open shutter and firing the flash by hand from different positions – taking care not to get the flash in the picture.

- **BEWARE OF LEAKING BATTERIES**
Never store photographic equipment such as flash units with their batteries in position. Leaking batteries can cause corrosion and severe damage to the equipment. If leakage does occur, brush off the metal connecting parts, remove the battery compartment – if possible – and rinse in hot running water.

TUNGSTEN LIGHT

All other forms of artificial light are based on the tungsten filament lamp. This lamp generates a certain amount of heat with the light: the more powerful the lamp the greater the heat.

The lights fall into three groups:

Spotlights which have a focused lamp and a lens so that the light can be directed onto a given area. The light is hard.

Floodlights which have a bulb in a dish-type reflector or have a silver reflector built into the lamp. This light is softer.

Quartz-iodine and **tungsten halogen.** These produce more light per watt than any other lamp and give a light quality somewhere between the spot and the flood.

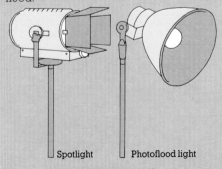

Spotlight Photoflood light

Bounced flash

If your flash unit has an adjustable flash head, make use of it for more interesting and successful lighting effects. Experiment, using all positions of the flash unit head, but you will have to observe certain rules – some of which are demonstrated opposite.

1 **Don't stand too close**
Do not stand too close to your subject. This will cause light to be reflected so steeply that little of it will reach the face of your subject.

2 **Correct position of flash head**
The flash unit should be positioned so that neither the subject nor the background receive any direct light.

3 **Working in small rooms**
Where space is restricted, try bouncing the light from wall to ceiling. If the wall and ceiling are white, the subject will receive more light than bouncing off the ceiling will provide.

4 **When ceiling is too high**
If the ceiling is too high, try bouncing the flash off the walls. Since the object is to provide soft light and no harsh shadows, there is no reason why the wall should not do as well as the ceiling.

5 **Suitable bounce surface**
If the wall or ceiling are any colour other than white, use a piece of white card or board placed so that the flash light will be reflected onto the subject.

6 **Close-up work**
Use pieces of white card to reflect the flash. This is the best way of showing the details of the subject.

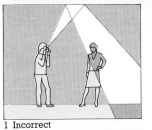

1 Incorrect

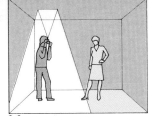

3 Incorrect

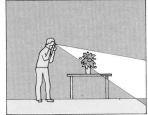

5 Incorrect

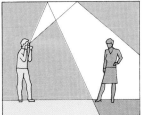

1 Correct

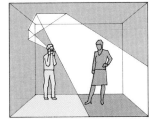

3 Correct

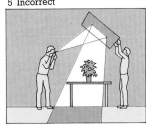

5 Correct

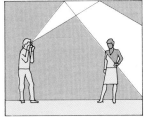

2 Incorrect

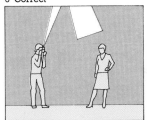

4 Incorrect

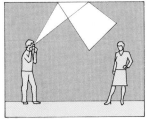

6 Incorrect

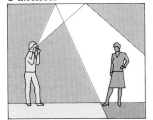

2 Correct

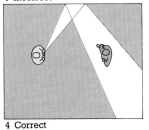

4 Correct

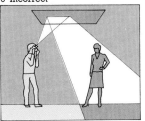

6 Correct

39

HAND-HELD LIGHT METER

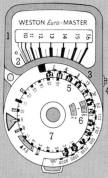

WESTON Euro-MASTER

◀ **Selenium cell type**

1 Light reading scale

2 Needle

3 Shutter speed scale

4 Needle release switch

5 Aperture setting scale

6 Film speed setting

7 Calculator dial

◀ **Sensitivity levels**

The baffle on the rear of the light meter should be up under normal light conditions (**A**) and down in poor light conditions (**B**). Use an invacone or diffuser for incident light readings (**C**).

A B C

HOW TO USE THE HAND-HELD METER

Set the ASA (or DIN) rating of the film in the window on the calculator (**6**) and point the meter at the subject. Press the needle release switch (**4**) and a reading will appear on the light scale (**1**). Locate this reading on the calculator scale (**7**) and adjust the indicator on the aperture scale (**5**) to align with it. The correct exposure and aperture settings will appear opposite the film speed setting (**6**).

Light meters/Exposure

To produce a well-exposed photograph some form of light measuring device is required. The hand-held light meter and the built-in light meter are the most common.

Light meters come in two forms: the selenium cell meter that gives a reading by generating a small current when exposed to light, and the CdS meter which, unlike the selenium cell is powered by a small battery making it more sensitive at low light levels. The SLR camera built-in meter is of the latter type.

Hand-held meters

Both hand-held types operate in the same way. The film speed is set in the ASA window and the meter pointed towards the subject, taking care not to pick up any light falling directly onto the cell because you are measuring reflected light. The reading given on the scale is then transferred to the calculator which will give the combinations of *f* stops and shutter speeds for a correctly exposed photograph. A reading directly from the light source can be taken from the subject position if the meter has an incident light adaptor. The reading is used in the same way.

Built-in meters

The built-in meter, CdS type, works in much the same way as the hand meter. The film speed is set and the reading taken through the camera lens. The viewfinder has a needle or a system of lights to indicate a correct reading which is obtained by adjusting the shutter speed or the aperture setting.

There are three types of built-in meter: the overall reading method which takes into account the lightest and darkest areas, the centre-weighted method which takes a reading from the major part of the central area, and the spot method which takes a reading from a small area only.

Through-the-lens meters are particularly valuable when using a variety of lens attachments. For example, when changing from telephoto to wide-angle the through-the-lens meter can be used to give a much more accurate and specific reading than hand-held types.

Care must be taken to obtain readings from the lightest and the darkest areas of the picture and use them to get an intermediate reading, otherwise one area will dominate the picture in exposure value.

BUILT-IN LIGHT METER

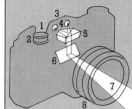

1 ASA (Din) setting
2 Shutter speed setting
3 Viewfinder window
4 Light sensitive cells
5 Pentaprism
6 Mirror
7 Light path
8 Aperture control

Built-in meters
There is a variety of available designs, but the principle in all is that the camera is the meter – taking a light reading through the lens. By adjusting the aperture and shutter controls the correct exposure reading will appear on the viewfinder display.

Viewfinder display

HOW TO USE A BUILT-IN METER
Set the **ASA** or **Din** rating of your film in the appropriate window of the camera. Set the most important control (aperture or shutter speed) depending on the kind of picture or subject you are taking. Focus the image through the lens and adjust the shutter speed control, or the aperture ring, until the indicator in the viewfinder display shows that the correct exposure is set. The usual type of indicator is a needle, which should occupy a central position on the display. Some of the latest cameras have digital electronic indicators, but the principle remains the same.

USING THE HAND-HELD METER

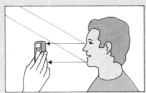

Reflected light method

Incident light method

Methods

To take a reading by the reflected light method, point the cell of the meter directly at the subject with the baffle up or down – depending on the level of light. The cell will record the intensity of *light reflected by the subject*.

The incident light method gives a more accurate reading for subjects from which you cannot take an average reading. Clip the diffuser over the cell and point it towards the light source to measure the *light falling onto the subject*.

Under exposed

Correct exposure

Over exposed

How to get the correct exposure

Correct exposure enables you to record the whole range of tones apparent in the image, without undue bias to light or dark *(left)*. To get it right you must take an accurate light reading. A reading from the darkest part of the image will result in over-exposure, *(above)*, a reading from the lightest part will result in under-exposure *(top left)*. The answer, in this case, is an average reading from the brightest highlights and the darkest shadows. You can use the meter to take an overall reading, but the light and dark tones of the image must be roughly equal in area.

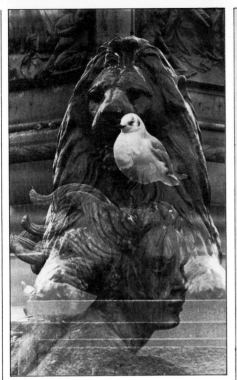

Double exposure
This is one of the simplest of 'special effects'. All you have to do, with most cameras, is to press the film release button after the first exposure and wind back instead of winding on. In making your choice of subject and effect, remember that the light parts of the first image are the parts that will show through the second.

THROUGH-THE-LENS METERS

Through-the-lens meters vary in the amount of light they measure. It is advisable to find out which kind of system is fitted to any camera you propose to buy – in order to be able to establish the correct exposure in your photographs. There are three basic systems: the average reading system, the centre weighted system and the spot reading system.

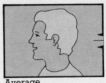
Average

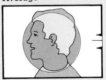
Centre

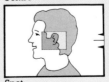
Spot

Average reading system
These view the entire picture area, averaging the light and dark parts to give an overall reading. This is only successful if the subject has roughly equal areas of each.

Centre weighted system
This system measures the whole area of light but with emphasis on the central area. This means that the centre must be typical of the whole picture.

Spot reading system
This system measures only a small part of the picture, but enables you to take several key readings and work out an average.

Portraits

The portrait can be approached in two basic ways: the formal and the informal. The formal may be in a studio or another setting but the relationship of the subject to the photographer will be direct and fairly rigid. In the informal, or even the candid, picture the subject may not know the precise moment at which the picture is taken and is thus caught off-guard. The photographer must decide, before the session begins and with the co-operation of the subject, which approach will be taken.

In a formal session, prepare as much as you can without the subject being present, have any lights you need ready and select the background, so that the job of taking the pictures can begin as soon as the subject is ready. If people are kept waiting they are apt to become uneasy and that can make things difficult even in a formal setting. Some people like to be told what to do and will feel more confident if guided. If the subject is too tense it may be necessary to engage him/her in conversation. Once the subject has been lined up in the viewfinder and focused, the photographer can, if the camera is on a stand, take pictures without looking through the viewfinder.

The problems that occur when photographing people and animals are very much the same, especially when trying to capture the mood and character of a subject that is not entirely willing to have its picture taken. Both animals and people have many expressions which indicate their moods and feelings and it is the photographer's job to capture those that give an indication of the subject's character. A portrait is only a likeness of the subject at the moment when the shutter was open.

When photographing special occasions, such as a wedding or any event which the participants will want to recall, try to capture the mood of the occasion and look for those impromptu happenings that will be remembered long afterwards. Try to build up a story which will hold the pictures together.

See also colour section pages 10/11

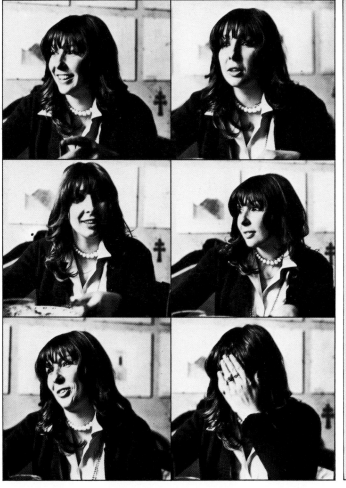

Informal portraits

Informal portraiture, in which the model is caught in many different attitudes, is a very effective way of using the setting to bring out the characteristics of the subject. It is important to have, or to make, a setting which will help to relax and animate the model. For the photographer, informal portraiture has the advantage that he can take photographs whether the model is ready or not.

Variety of pose

Make the most of your model and take plenty of pictures. This makes it easier to get the results you want and it helps the model to relax.

45

Lighting portraits

Lighting for portraiture is not difficult unless you try to be too clever. There is one basic principle for the beginner to follow: if it looks natural, it is right. Avoid direct hard light that will give strong shadows. Even when shooting in sunlight find a position that will give an indirect light – it will be much easier for both subject and photographer.

When using artificial light, set the main light first. This will provide some shadow, giving the subject body and dimension. Position the light above the subject and slightly to one side to start with, then try alternatives. If the light is positioned on one side, almost on a level with the subject, half the face will be in shadow. If detail is required in the shadow area, another light source will be needed to fill in. A white reflector is ideal because it can be positioned at any point away from the subject to increase or decrease the amount of fill-in without creating secondary shadows. All lights, and particularly flash, are best bounced off a white reflector if you are not used to lighting. Remember that a smooth surface reflects hard light, but an irregular surface scatters light – making it soft.

CAMERA POSITION

Camera position is important in portraiture: because the camera will distort, it can be used to enlarge a weak feature or diminish a strong one. Remember, the face has two sides and they are never identical – so look for the better side.

A wide-angle lens, used close, will distort features.

At a similar distance, using a standard lens there is no distortion.

With available light

Available light with flash

Lighting effects
These pictures were all taken with very simple lighting. This page, *top,* shows the effect of using available artificial light – in this case a spotlight, but not under the photographer's control. In similar circumstances it may be necessary to use flash, *below left,* in addition to the available light. The opposite page shows the contrasting effects of reflected light. Backlighting, *top,* producing a sharper effect than sidelighting, *below.*

47

Group portraits

There are many occasions when you will want to take a group portrait, but try not to do the obvious every time. When photographing the line-up of the football team look for objects or backgrounds that will give the picture more meaning. For example: position the goalkeeper and the defenders together in one side of the goal and have the rest of the team closer to the camera, using the goal as a frame for the whole picture. If it is a smaller group, position them around a common object to give them a point to relate to. Be aware of what is happening in the background. The subjects should not have trees growing out of their heads or any strong single line cutting the ground behind them.

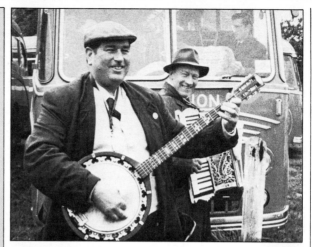

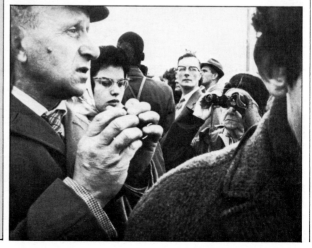

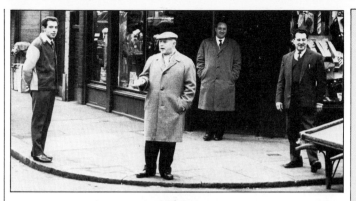

Handling groups

The differing styles of group portraits are well demonstrated by these pictures. The musicians, *far left top*, have been posed, but with instruments as props and the off-duty bus driver visible, the picture has an easy, relaxed quality. The racecourse group, *far left bottom*, is completely informal – the foreground figures being used to frame the different expressions and positions of the others.

The street corner group, *top left*, has been left to adopt its own poses. The picture is made more interesting by the different levels of camera consciousness of the people within it and by their differing relationships to the background. The differences in position – some posing, some not, give the picture its character. The more formal group, *below left*, has been arranged to suit the photographer's wishes, but taking account of the significance of the location and background.

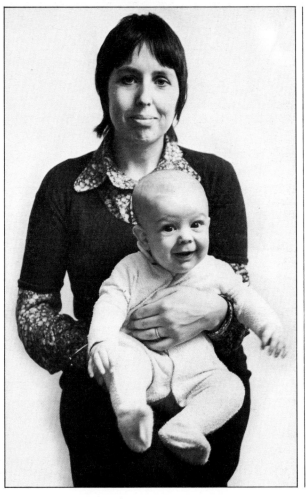

Children

Children are best photographed informally, while their attention is distracted. Give them something to do, or to play with, and then just wait until you see a good picture. A fast shutter speed is advisable to stop movement and, if you have to use light, use flash because it will be less distracting.

Natural positions
Look for the positions and angles that only a child will adopt.

Children as subjects

The typical family archive picture, *far left*, depends upon charm and the mother/child relationship. By way of contrast, the two candid pictures, *left*, depend upon capturing the moment. In the picture on the right the moment of aggression and tension is at its height. The unusual picture, *below left*, uses the windows to frame the children in a setting in which they are completely relaxed – with intriguing reflections added for good measure.

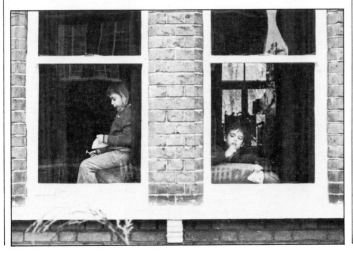

Formal pose

It is wise not to be too formal with children – this pose is ideal.

51

Photographing animals

Animals are the most difficult subjects for the beginner because they are so unpredictable and cannot be reasoned with. It is a question of watching and waiting, having the camera ready at all times.

With domestic pets you can get to know their favourite games and haunts; by using a telephoto lens you can get some interesting pictures.

Food can be used to get wild animals into a suitable position to photograph but care should be taken not to disturb them with noise. Again, a telephoto lens will help but if you still find the animal or bird is frightened by the shutter noise, wrap the camera with foam rubber to deaden the sound.

Animals in a zoo present their own problems, but they are easier to overcome. The main difficulty is getting rid of the bars or other cage material. The telephoto lens is useful: it can be placed close to the wire or positioned between the bars or, if that is not possible, the limited depth of field can be used. With the cage close to the camera it will not appear in the picture but just act as a diffusing screen making the picture slightly soft.

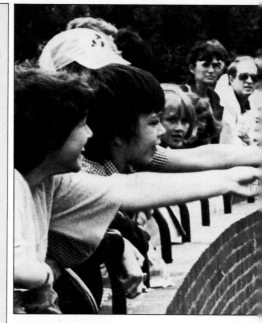

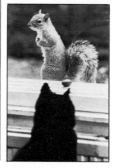

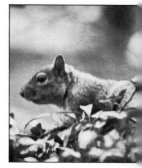

Animal models

Animals provide the photographer with an unending variety of possibilities. Not only do they lend a great deal of charm and amusement, especially when photographed with people, *top left and below*, but they are also perfect for studies in texture, *right*. The naturalist may want to specialise in animal studies, *below left*, but anyone would be delighted to catch a moment of confrontation between two animals, *far left*. The very unpredictability of animals is the source of a great deal of pleasure, so it is usually worthwhile to persist with difficult subjects – you will eventually get the result you want.

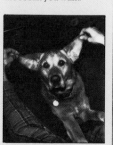

Stopping and 'freezing' action is something that is unique to photography. It is what all photography is about: the isolation of one moment in time. It is relatively easy, given the right conditions and equipment, to freeze action in a photograph, but often the whole point of an action picture is lost by doing just that. A degree of movement in the picture may be required to emphasize the action.

The use of shutter speeds, panning and camera angle will all describe movement in some way. The juxtaposition of a number of prints of an action taken at different times from a fixed camera point can give a feeling of time and action. Colour can be very effective in action photographs.

When shooting action photographs you need to have your camera ready to shoot at all times and be prepared to use a lot of film to get the best pictures.

See also colour section pages 14/15

Preparing for action

To get successful action photographs, speed of camera operation is essential so the camera should be ready at all times. A knowledge of the activity you are trying to photograph will also help. Those activities that follow a regular course or pattern will be easier to photograph than a spontaneous action.

The zoom lens will be most valuable for action photography because you can change from telephoto to normal lens with the camera at your eye. The wide angle will also be useful for the more contrived shots. The low or acute camera angle can give a photograph a strong feeling of action because the subject is shown at an exaggerated angle in the picture.

If the subjects are under your control get them to run through the action so that you can look for the most interesting points to photograph and also practise following the action with the camera. When taking sporting pictures, position yourself where you can best follow the action and where the action is most likely to take place. Always decide carefully what you are trying to show with the photograph. The correct technique for one may be completely wrong for another.

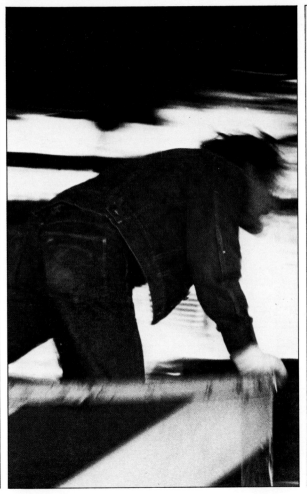

Camera in action

Good action photography demands the smooth and effective use of several different camera techniques. Two of them are illustrated here: the effects of **panning**, *left*, combined with camera movement, and **freezing**, *below*. These, and other techniques will be described on the following pages. The skill required to take pictures such as these is not hard to acquire, but you should take advantage of every opportunity to practise your technique. You can do this not only at sporting events, but in countless everyday situations where movement is dramatic, complex or evocative. You need no special equipment for action photography, but a zoom lens will enable you to have a considerable range available without having to change lenses or take the camera away from your eye.

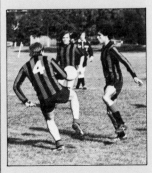

Techniques for action

Freezing Action

The obvious way to freeze action is to use a fast shutter speed or a flash unit on the camera. A shutter speed of $\frac{1}{500}$th or $\frac{1}{1000}$th will stop most action – so long as you are not also working in close-up. The closer the action to the camera, the more exaggerated the movement.

A subject moving across the camera in parallel will show more movement than one coming directly towards the camera, so a slower shutter speed could be used on the latter.

Certain motions have a freeze point in them, for example, when an object is thrown up in the air there is a moment between its ascent and descent and some skilled photographers can catch this moment, but it takes a sound knowledge of the activity involved.

Panning

Panning is a technique which involves stopping the movement of the subject and blurring the background. This gives a feeling of movement but keeps the subject recognizable. Depending on the speed of the subject, shutter speeds as low as $\frac{1}{30}$th second can be used, the photographer using his own experience to choose which speeds will suit his subject. First, set the shutter at the appropriate speed and choose a background that has a contrast of light and dark areas or colours – if you pan against a plain background there is nothing to blur. Focus the camera on a point opposite the camera through which the subject must pass. Relax your body and turn the trunk so that you can frame the subject as it approaches. Follow the subject, keeping it in the chosen position in the frame by turning your body. When the subject is opposite the camera trip the shutter gently and follow through with the subject – if you stop at the shooting point the whole picture will be blurred.

Fixed Position

The opposite to panning can be very effective. By placing the camera on a stand and using a low shutter speed the background will be sharp and anything passing in front of the camera will be blurred. This can be useful when photographing buildings when there are people walking about: by having a long exposure the people, if they are constantly moving, will not register on the film at all.

Action techniques
These three pictures illustrate the main techniques for depicting action. In the head-on shot, *right*, the subject is effectively 'frozen', but in the picture taken with the camera in a fixed position and the subject moving across the lens, *far right*, the movement is in the subject itself. Panning, *below*, creates the effect of movement by fixing the moving subject and blurring the background.

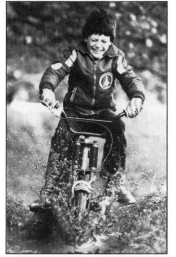

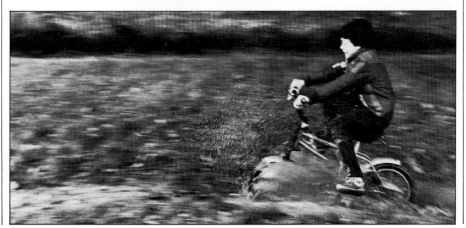

Effect of movement

Camera movement
Moving the camera during a slow exposure can produce some interesting effects, particularly with colour film.

Zoom lens
A way of producing the effect of movement in a picture with a still subject is to use the zoom lens. Set the camera on a slow shutter speed with the camera on a stand, focus the lens at its shortest length and, while the shutter is open, zoom in. The centre of the picture will be sharp but the area around it will blur.

Flash technique
A flash technique to produce a blurred and sharp picture is to shoot on a long exposure and fire the flash during the exposure to freeze the action at that point, this will give the effect of a moving and a frozen subject in the same photograph.

Films & Filters
Fast film and a polarizing filter will be useful in action photography, the first to give fast shutter speeds, the second to give slow shutter speeds.

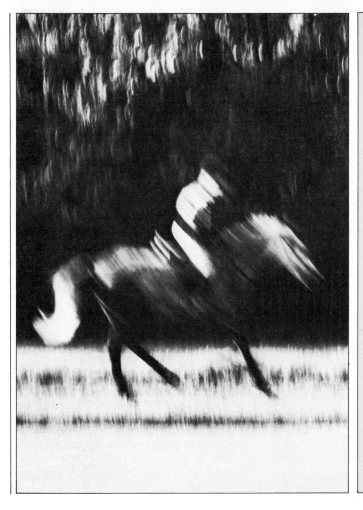

Action effects

Action photography is one area in which almost anything goes. The effect of considerable movement in the picture of the horse and rider, *left*, has been obtained by moving the camera during exposure, but not in the way that has been described for panning. This effect requires an erratic movement at the moment of exposure. On the *opposite page*, the top picture illustrates the extraordinary effect of flash on movement. The contrasting aspects of sharpness and blur are, in fact, part of a continuous sequence of movement but the flash has frozen part of the movement at some point during the exposure. The bottom picture shows how movement can be created in a picture where the subject is stationary. This can only be achieved with a zoom lens, but the technique is quite simple. All you have to do is 'zoom in' on the subject while the shutter is open.

Selecting the picture

To take interesting landscape pictures you do not need to travel to exotic places, just take a short walk around the area you live and there is a good chance you will find something interesting to photograph, it may even be in your own garden. Landscape is more than picturesque country scenes: it includes all aspects of our environment, the city and the industrial landscape as well.

An interesting aspect of landscape photography is that the subject is constant in its position and nature provides the changes in terms of weather, light, etc. This means that if you are not satisfied with your results, you can return to the subject at any time to look for a better picture. The dedicated landscape photographer must be prepared to spend time looking and waiting for the right conditions to produce a good picture.

See also colour section pages 18/19

Some landscape photographs can be very dull. This is usually due to the photographer trying to capture the grandeur and space he feels in the location by including as much as he can in the picture. So, by the time the photograph is reduced to its viewing size the scene can look empty and dull. It is better to look for a smaller area which is indicative of the scene and by careful composition and camera angle create the illusion of space.

The first step to better landscape photographs is to establish a point of view, not only with the camera, but in your mind – about why a particular scene is worth taking. Most landscapes will have a dominant feature around which the picture can be constructed. This feature may, of course, change with the point of view you adopt in your mind. By placing emphasis on one area to establish a key point, the eye can be led to and from this point by linear perspective (lines that converge on to the key point). This establishes the relationship of areas of tone or colour from the viewer to the key point and then to the horizon line. Both of these will help to give the picture depth and a feeling of space.

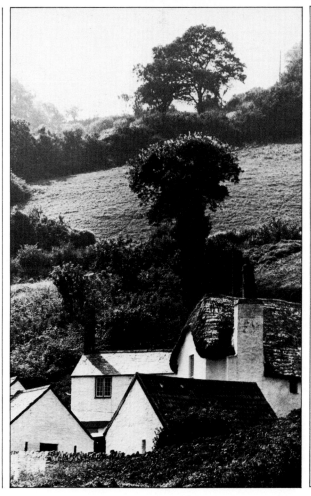

Composition

These pictures demonstrate some of the most important elements of landscape photography. The group of buildings, *left,* is framed by its own landscape and forms an integral part of it. The eye is lead through the picture by the almost parallel lines of roof and hedgerow. The eye should never have any difficulty in travelling from one part of the picture to another, but should be lead in a way that takes in the landscape as a whole. This fails to happen when the photographer tries to include too much in the picture.

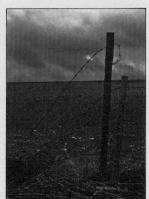

Be selective

This picture shows how a very small area can be used to give a clear impression of the whole landscape.

61

STRUCTURE

In general terms, there are two basic structures in landscape photographs: the open view – rolling countryside or a seascape, and the closed view – a wooded lane or a city street.

The first tries to put the viewer in the centre of the landscape, whereas the second may be a revelation of a small part of the overall landscape. Once a general area has been decided, it may be necessary to look around for a while to find the most interesting point of view and also to establish the direction of the light. It may also be necessary to wait until the quality of light has improved sufficiently to take the picture. If you are photographing a well-known view or building, avoid the obvious viewpoint.

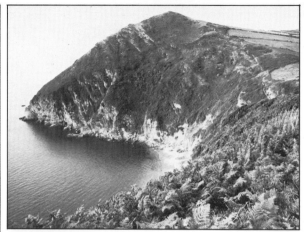

Open landscape

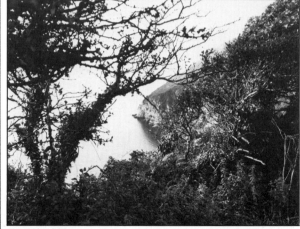

Closed landscape

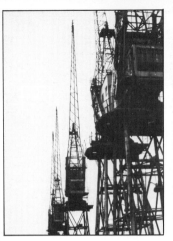

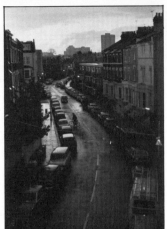

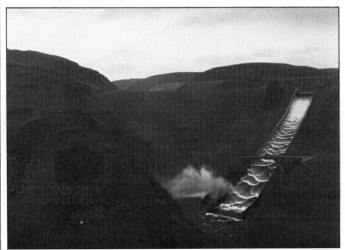

The point of view

The pictures on the opposite page illustrate the difference between open landscapes, *top,* and closed, *bottom.* In the bottom picture the foreground foliage allows just enough of the distant bay to show through for the coastal effect to be made. On this page, the low angle used for the cranes accentuates the perpendicular structure and makes them stark against the sky. The high angle used for the street scene enables the photographer to show the street as part of the city landscape and to make the most of the evening light. The unusual view, *below left,* has several curious elements. Not only is the combination of man-made and natural features a striking part of the picture but the distant hilltops make the picture more intriguing by their strange similarity to each other.

Lighting & landscape

Once the point of view has been established, the time of day, the season and the weather are the next considerations because all affect the landscape photograph, especially its drama and mood, and are an essential part of this area of photography.

As a general rule, it is best to avoid the middle of the day: photographing with the sun at its zenith will make the scene look flat and uninteresting. The sun in the early morning and late afternoon will give stronger, more defined shadows that will help to separate areas and also produce texture that will give the picture a stronger sense of three dimensions.

Your point of view may have to change once you have observed the effect of the light, or you may have to wait for a different time of day if, for example, you find yourself shooting directly into the sun.

Sunlight in winter is good to work in because the sun is lower in the sky, giving more contrast and definition. The sunsets and sunrises at this time of year seem more dramatic. Evening sunlight will have a similar effect, but the quality of the light in mid-summer is harsh.

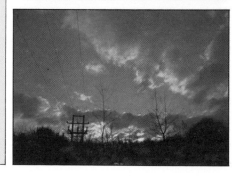

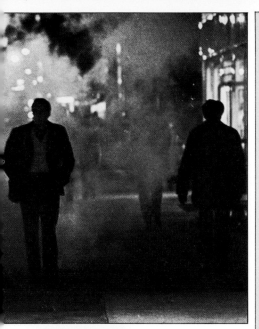

Natural effects
The combination of available light and the atmospheric conditions of the street scene, *above*, make a dramatic urban landscape. The evening light, *far left*, is the exciting element in this landscape, while the shaft of sunlight in the detail picture, *left*, accentuates the land formation.

FILTERS FOR LANDSCAPE

There are four filters which are of considerable value in landscape work:

POLARISING FILTER *colour*

Will darken a blue sky and improve the colour saturation of objects which have a reflective surface.

ULTRA-VIOLET FILTER *colour*

Removes the blue cast which occurs most noticeably in landscapes and is invisible to the human eye.

RED FILTER *black and white*

Darkens the sky and makes the clouds appear lighter, but detail of vegetation will be lost.

YELLOW FILTER *black and white*

Also darkens the sky and adds to the contrast, but not as much as red.

Polarising filter: The same subject, without filter, *right*, with filter, *left*, showing how reflection is diminished.

Red filter Yellow filter

The weather

Many beginners consider it impractical to take photographs in anything other than sunny conditions, but other weather conditions do offer the photographer the opportunity to get unusual and interesting pictures but care must be taken to protect equipment in wet weather. With modern film materials and fast lenses, dealing with bad light conditions, particularly if you have a tripod, is no longer a problem. A tripod will also allow you a free hand.

Photographs of street scenes, or of buildings at night, can be improved if shot in or after a rainfall. The lights from buildings and vehicles reflected in the streets and windows are particularly effective in colour. Metallic objects, and close-ups of plants and flowers with water droplets on them are often more interesting this way.

Fog will isolate a foreground object from the background giving the picture an ethereal quality. By shooting directly into the sun the flare created can give the impression of heat. If you wish to have the sun in the picture without flare you will have to expose for the sun and let the rest of the picture take care of itself.

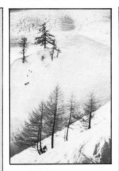

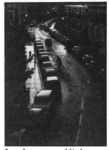

Landscape and light
Sometimes, the most difficult aspects of weather are those which provide the best photographic effects. Rain, *above,* and fog, *right,* are good examples. Snow scenes, *top,* reflect a lot of light, so you must be careful not to over expose. When using the camera in rain, remember to fit a lens hood.

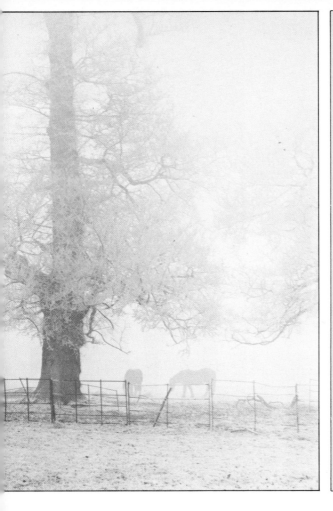

EXPOSURES

The general rule for landscape exposure is to take readings from light and dark areas in order to find a medium exposure. Be careful not to over-expose with readings from skies, seascapes and snowscenes.

Light reading for sky

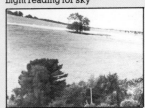

Light reading for land

An average taken from two readings should give the correct exposure where land and sky are roughly equal in proportion.

Photographing buildings

The same rules apply to buildings and cities as to landscapes, but there is an added aspect of function. Your approach to the subject should be influenced by the function of the building or area whether historic, religious, social or industrial. A number of pictures may be needed to describe a building or place so don't be afraid of showing more than one picture of the same location. Most buildings have been designed to have a dominant aspect which will then lead the observer to other aspects of the building. Once you have explored these, look for other views and then move closer to the building to note details of the structure such as decoration, doors, windows etc. Remember that buildings are built to a scale appropriate to their function, so a figure or a vehicle included in the picture will give the viewer an idea of size.

It is often impossible to get a clear view of buildings even with a wide-angle lens. Alternative views can be found in reflections in a wing mirror of a car or in the window of a nearby building. It may be necessary to take a distant view and enlarge it, cropping out unwanted material.

Architecture

Buildings may be impressive as part of the landscape, *opposite page top*, or in their own right, *below*. The reflections in a puddle, *opposite centre*, give an interesting distortion while still revealing the character of the building. Unusual objects and details, *opposite*, help to give a more complete impression of large buildings. People can be helpful as a measure of scale, *left*.

Wide-angle lenses

The picture *above*, was taken from a low angle of view using a wide-angle lens – a type which is invaluable in the photography of buildings.

69

Photographing interiors

Interior photography can be difficult for the beginner – mainly because of the extremes of lighting and the lack of space. Avoid taking pictures in a room where the sun is entering directly, unless that is the particular aspect you are trying to capture. Wait until the light gives less contrast or shoot on an overcast day, if necessary. If you wish to use supplementary lighting make sure it does not overpower the existing lighting to give an unnatural effect.

Door frames and windows can be used to frame pictures with a restricted view to give the feeling of entering a room or looking into it.

If there are too many people walking about and spoiling the picture a long exposure can be used to eliminate them – so long as they keep moving!

CORRECT EXPOSURE

Getting an exposure that is correct can be a problem; very often you will have to decide which part of the picture you wish to expose for light or dark. Very often the extremes of light are so great that a middle exposure will give you a bad result.

Indoor work

Interiors offer as many good viewpoints as landscapes. Sometimes, looking through the building and beyond, *left,* is very effective. Using windows, arches or doorways, *below,* to frame the interior is another way to improve the composition. Working with available light can be difficult, but where windows are an important feature, *below left,* the result can be very satisfying. In public places, the constant traffic of people will pose a problem. But an extra long exposure will eliminate them, *far left top,* unless they stand still in front of the lens. Details, *far left bottom,* can reveal the character of a building – even in isolation – so look out for possibilities.

STILL LIFE

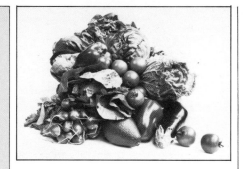

Creative still life gives the photographer an opportunity to exercise almost complete control over a picture. The selection of subject, background, composition and lighting will all be entirely in the hands of the photographer. But, before selecting your subject, you must establish the overall concept of the still life. Are you looking for atmosphere, colour, tone, composition – or a combination of qualities?

If you have a clear idea in mind, the business of selecting and setting up the still life will be a lot easier. Start by working with a single object and try to light it and photograph it in as many ways as you can. Add other objects to make the composition and lighting more difficult. In this way you will see more clearly the problems involved in still life photography.

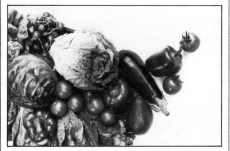

See also colour section pages 22/23

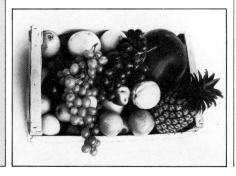

Experimenting with props
Starting with a selection of props,
in these examples fruit and
vegetables, try a variety of
arrangements and photograph
them from several angles and
distances. You can see, by
comparing the top two pictures,
left, that the change of camera
position changes the composition.
The effect is similar in the slightly
more formal arrangement of the
boxed fruit, *bottom left and below.*
By introducing another prop, and
making the composition more
formal, *right,* you will be able to
familiarise yourself with the
related problems of composition
and lighting. Be careful not to
neglect the background in this
work, always assess your
composition against the
background with the lighting you
intend to use. Take plenty of time
to set everything up to your
satisfaction.

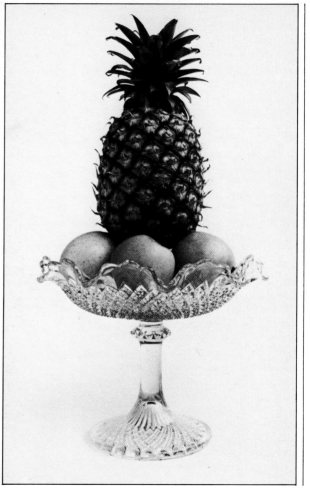

73

Subject/Background

The selection of subject matter is of the greatest importance because it will control the whole feeling of the photograph. The choice of subject will dictate the lighting, background and composition. The subject may be used to convey a number of things: to generate an atmosphere or to show lighting, texture, tone or colour in an abstract sense.

Background

After deciding on the subject, the background must be chosen. If you decide on a simple ground of colour or texture make sure you have enough material for the subject to sit on with plenty of space all round. Allow enough space between the subject and the backdrop for both to be lit independently if necessary; the background light should not spill over onto the subject. Position the camera, preferably on a stand, square to the background and construct the composition through the camera viewfinder. Avoid turning the camera to one side or the other because you may run off the background.

When using available light, the camera and background will be fixed by the direction of the light.

Experimenting with background
The effect that background has on the subject is amply illustrated by the pictures on the *left*. In the *top picture*, the highly reflective glass background gives a quality of freshness to the subject, but the *middle picture* with its more natural, but coarser, background almost suggests decay. The *bottom picture* uses background and props to give the fish an edible attraction which the other pictures do not have. Remember, when using highly reflective surfaces, to avoid too many highlights. Glass, especially, is apt to cause flare. In the still life arrangement, *right*, the group is lit from the front and top in order to prevent shadows falling across the cans at the back of the group. This gives a very even overall tone to the background. Make sure that you have enough background to fill the frame – if not, you will have problems later when cropping the prints. Remember, what you have on the print is what you see in the frame.

Composition & lighting

Composition

Having set the background and the camera position, select from your subject material the things you consider vital to the picture and place them or it against the background. The relationship of the group or single object to the camera viewfinder forms the basis of the composition. The object or group may form a strong vertical shape and this may lead the picture to an upright format. Most objects or groups form or suggest a pattern which will give a direction to work to. Start with the main elements and then build the subordinate elements around them. Try to lead the eye to the main subject in the picture or, if there is no dominant object, position the elements in a pattern that will lead the eye from one to the other in a rhythmic way.

Lighting

Once the basic composition is established you can begin to light the picture. Some rearrangement may be necessary once you see the full effect of the lighting through the camera. Again, the composition and texture of the subject will give a strong indication of how the subject should be lit.

Textures and found objects

Many of the objects that you encounter in daily life make suitable subjects for photography. Perhaps because of their texture, *far left*, or because of their shape and form, *below centre*, or because of their originality, *left*. Sometimes the juxtaposition of the natural and the man-made produces an intriguing textural picture, *below left*. Here, the effect is more striking because a feature is being made of things that we would usually take for granted.

Close-up photography

With still life photography you are sure to get involved with the use of close-up attachments or lenses. Whatever method you choose to work with, make sure your through-the-lens meter will work with it. If the meter is rendered inoperable you will have to find an alternative meter for light readings.

When working in close-up, the depth of field is severely restricted and any movement with the camera or by the subject can cause the picture to go out of focus. The camera will be better on a stand and, if the subject is likely to move, hand-hold the camera to bring the subject into focus. If you try to focus on a moving subject in close-up you may never get it sharp; it is quicker to preset the focus and move the camera.

When photographing plants or insects in their natural setting, a simple light screen around the subject will cut down any movement caused by wind, but care must be taken not to have the screen in the picture unless you are trying to isolate the subject from a busy background. The white reflector will be useful to get light under a plant or flower, or any subject where it is important not to lose the essential detail.

Close-ups and details

Much of close-up photography is concerned with the recording of details or small areas of specific effects. Often the result is unusual, even puzzling, as in the picture of wine bottles in a rack, *opposite page top*, and the rain on glass, *bottom*. The centre picture, however, is a straightforward and instantly recognisable detail shot which might be taken as part of a group of pictures or as a textural shot. For many people, close-up photography comes into its own with the study of animals, flowers or insects, *left.* This requires a technique which the naturalist will quickly learn – the only real problems being caused by the use of screens and reflectors. The former to prevent movement by wind, the latter to prevent loss of detail in shadow. Whatever your interest, close-up work should form part of your photography. It is not only a very useful technique but also a very satisfying one.

The human body is a challenging
subject for the photographer, and the
nude can be the most challenging of all.
When photographing the body we are
trying to show grace and movement in
a universal sense rather than trying to
capture the character and personality
of an individual. We may try to express
such things as mood and emotion as
well. If nude photography is
impracticable or just does not interest
you, but you are, nevertheless,
interested in the human form, the
natural positions and actions people
adopt while working or playing can be
just as exciting and challenging to
photograph. But, as in action
photography, you will need to be quick
to capture the best pictures.
A good sense of composition is also
required – and an ability to capture the
shapes and lines the body forms.

See also colour section pages 26/27

Form in natural positions

The unconscious pose, *far left*, is charming because of its innocence and natural elegance, while the family record picture, *below*, is quite simple and without pretension. Humour can play an important part, *top left*. Here, the juxtaposition of the still life and the real person emphasises the human form. Portraiture can come into this category, *below centre*, while the distorted effect, *below left*, contrasts the human form with the elements.

81

WORKING WITH A MODEL

If you are using a model for your photographs, that is, if you are controlling and directing the person, it is important to establish a relaxed working relationship. If the model is in any way tense or embarrassed it will show in the picture. The nude is a difficult subject for this reason, but if you give the model confidence in you and him- or herself it will help a great deal. Also, let the models feel they are contributing to the photograph by allowing them to suggest poses.

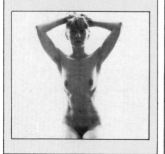

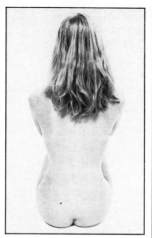

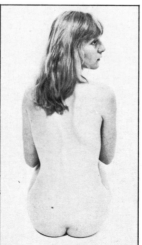

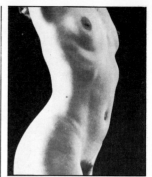

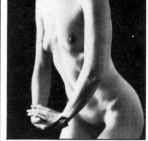

Variety of pose
These pictures show how a considerable variety of poses can be achieved without elaborate and drastic changes of position by the model. The best way to achieve natural and relaxed poses is to make subtle and gradual changes from one to the next. This helps the model to achieve a pose which feels right and the photographer does not have to keep moving around the model.

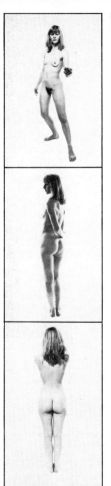

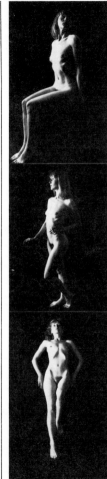

LIGHTING

Lighting is all-important to the photography of nudes, so care should be taken not to over-light the model giving hard shadows and too strong contrast to the body, thus killing all the subtle skin tones. Use a soft light source, such as daylight from a window, or bounced artificial light, to give the body shape and texture.

If you choose to work outside, avoid direct sunlight and look for a background that will be sympathetic to the model and any idea that you may be trying to evoke.

A lot of people today travel to warmer climates for holidays and this can be an ideal opportunity to take nude photographs.

When choosing backgrounds remember that texture, as well as colour, is important. A contrast of skin textures can lift a picture considerably. If you choose to work on a plain background and use props, keep them as simple as possible.

The body used in an abstract form can be a good vehicle for lighting tone and texture as well as line and form.

Basic home darkroom

In a darkroom you will need two main services – water and electricity – and in most domestic situations these are found together only in the kitchen or bathroom. Therefore, if it is not to be a permanent room the home darkroom must be a compromise.

The best thing to do is to find a room that has electricity and can be blacked out with ease. A static water supply can be brought to the room in a pail or bowl. A working surface for both wet

and dry activities will be required and a place to store equipment, chemicals and photographic printing materials.

The room will need to be totally dark only for the time it takes to load the film into the developing tank. The majority of the time will be spent in semi-darkness.

Keep the wet and dry areas as separate as possible and always keep both working surfaces and equipment clean.

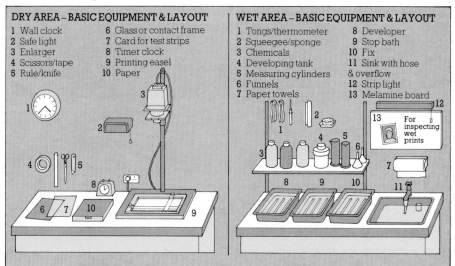

DRY AREA – BASIC EQUIPMENT & LAYOUT
1 Wall clock
2 Safe light
3 Enlarger
4 Scissors/tape
5 Rule/knife
6 Glass or contact frame
7 Card for test strips
8 Timer clock
9 Printing easel
10 Paper

WET AREA – BASIC EQUIPMENT & LAYOUT
1 Tongs/thermometer
2 Squeegee/sponge
3 Chemicals
4 Developing tank
5 Measuring cylinders
6 Funnels
7 Paper towels
8 Developer
9 Stop bath
10 Fix
11 Sink with hose & overflow
12 Strip light
13 Melamine board

13 For inspecting wet prints

DARKROOM EQUIPMENT CHECKLIST

1 Thermometer
2 Measuring cylinders: 2 x 600ml
3 Storage containers for chemicals
4 Chemicals: developer and fix
5 Plastic funnels x 2
6 Short plastic hose
7 Tap attachment
8 Film developing tank
9 Timer clock
10 Dishes x 4
11 Film clips
12 Film and paper wipers
13 Printing paper
14 Contact printing frame •
15 Glass alternative to 14
16 Enlarger
17 Safelight
18 Plastic bowl or pail •
19 Print forceps or tongs •
20 Rubber gloves •
21 Paper kitchen roll
22 Wall clock •
23 Film inspection board •
24 Squeegee/sponge •
25 Printing frame/easel

• Useful but not essential

Chemicals

Chemicals can be bought as concentrated solutions or ready-to-mix powders and most film and paper manufacturers will suggest the appropriate chemicals for their materials.

Developers

Separate developers are required for film and paper. We recommend the 'one-shot' types that are discarded after use.

Fixer

A Universal Fixer can be used for both film and paper. As this is mixed to different concentrations for film and paper it should be stored in marked containers.

CAUTION

All readily available photographic chemicals are safe to handle but care should be taken while using them. All spilled chemicals should be cleaned up at once, and discarded chemicals should be diluted with water before pouring down the drain. All processing equipment should be thoroughly cleaned before storing away after use.

IS YOUR DARKROOM LIGHTPROOF?

If you wish to test that your darkroom is light-safe for film loading, place a strip of unexposed film in the dark for five to ten minutes, then process it. If the film is clear after processing, the darkroom is light-safe. For printing, follow the same procedure with the safe-lights in the regular positions. Place a sheet of printing paper on the enlarger bed, or where the developing tray would stand, put an object on the paper and leave it for the same length of time. If no outline of the object appears on development, the room is safe for printing. Remember, that once the film or print has been processed and fixed it can be taken into a lighted room which has running water to be washed.

How to develop film

Follow a set system when developing film, if any adjustments or corrections need to be made they will be easier to judge. Keep all equipment clean and dry – if it is meant to be dry. Handle the film with the utmost care at all times, keeping your fingers off the surface and handling only at the edges. Follow the manufacturers instructions for dilutions, temperature and development time.

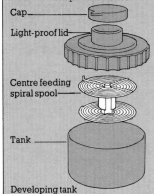

Cap

Light-proof lid

Centre feeding spiral spool

Tank

Developing tank

PREPARATION LIGHTS ON **1**

1 Lay out all your equipment so that you can find it easily in the dark.

DEVELOPING TANK
DEVELOPING TANK LID
DEVELOPING TANK SPOOL
TIMER CLOCK
OPENER FOR FILM CASSETTE
SCISSORS

2 Have your chemicals ready at the correct temperature: 20° C (68° F)

DEVELOPER
STOP BATH SOLUTION
FIXER
WETTING AGENT

3 Pour the developer into the tank ready to accept the loaded spool. Keep the developing tank immersed in water at 20°C (68° F). It is important to maintain this temperature throughout the processing time.

4 Trim the end of the film square, if the film is visible. If not, you will have to do it in the dark when you have unloaded the film from the cassette.

5 Set the timer to the correct developing time – *see manufacturer's instructions.*

Water
20° C (68° F)

LOADING TANK **2** LIGHTS OFF

1 Open the film cassette – you can use a bottle opener for this.

2 Trim the film end square, if you have not been able to do so already.

3 Attach the end of the film to the clip at the centre of the spool.

4 Feed the film into the spool, bowing it slightly. Let the film follow the spiral construction of the spool.

5 Cut, or tear, the film from the cassette spindle – tucking the cut end neatly into the spool.

6 Insert the loaded spiral into the developing tank and close the light proof lid tightly.

7 Release the pre-set timer

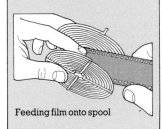

Feeding film onto spool

DEVELOPING LIGHTS ON **3**

1 Tap, or gently agitate, the tank to release any air bubbles from the film surface.

2 Agitate the tank for 10-15 seconds in every minute throughout the developing time.

3 When the timer signals the end of developing time, pour the developer away. Do not remove the light proof lid.

4 Fill the tank with stop-bath solution until it overflows. Agitate the tank and leave it for about 60 seconds. Pour the solution away.

5 Set the timer to the correct fixing time.

6 Pour the fixer into the tank until it overflows.

7 Release the pre-set timer.

8 Agitate the tank for 10-15 seconds in every minute of fixing time.

Agitate for 10-15 seconds in every minute

WASHING/DRYING LIGHTS ON **4**

1 When the timer indicates that fixing is complete, pour the fixer out of the tank.

2 Put the tank in the sink, remove the lid, attach a hose to the tap and run water through the tank for about 30 minutes.

3 Remove the hose and pour the water out of the tank. You can now bathe the film in a wetting agent for about 3 minutes to encourage even drying.

4 Remove the spool from the tank, attach a clip to one end of the film and unwind it from the spiral. Hang the film in a dust free drying place.

5 Gently sponge each side of the film to ensure that no water droplets remain to mark the negative.

6 When the film is dry, cut it into convenient strips – about 6 negatives in each – and store them in special bags to protect them from dust and abrasions.

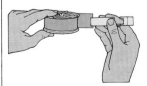

Attach clip to end of film

USEFUL TIPS **5**

Loading films onto the spool of a developing tank can be difficult at first, but it is essential that it is done correctly. If the film touches any part of itself while on the spool it will not develop properly. You will find it helpful to practise first in daylight – using a damaged or discarded film.

If you do not wind the film all the way back into the cassette after a photo session, the tail which protrudes can be trimmed square and attached to the centre of the tank spool in daylight – making the process a lot easier.

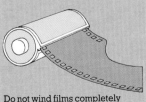

Do not wind films completely back into cassettes.

How to make contact prints

Contact sheets – prints made by exposing a sheet of printing paper while in direct contact with strips of negatives – offer the best method of selecting the negatives which you will enlarge. A 36 exposure film, or a 120 will fit on a sheet of 20cm x 25cm (8in x 10in) paper when cut into strips of six negatives. With contact prints you can make a careful comparison of all shots on the film. After you have made your choice, the contact sheet can be kept as a record of your work.

Contact printing frame
You can buy special contact printing frames which greatly simplify the process. You just insert the negatives, printing paper – and expose.

PREPARATION 1
LIGHTS ON

Set out your contact printing equipment in the most convenient order and check that it is all present and serviceable. You can use the enlarger as a light source but you will also need the following:

DEVELOPING DISH
STOP BATH DISH
FIXING DISH
APPROPRIATE CHEMICALS AT 20° C (68° F)
PHOTOGRAPHIC PAPER
CLEAN, UNSCRATCHED SHEET OF GLASS
OR CONTACT PRINTING FRAME
BUCKET OR SINK FOR WASHING

Fill the dishes with sufficient chemical for the job and have the bucket or sink filled with clean water for washing. Make sure the contact frame or glass is clean, unmarked and dry.

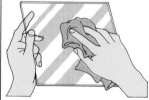

If you use glass, try to get plate glass – it is best and safest.

PRINTING 2
SAFE LIGHT ON

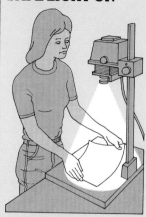

Fixing light source and positioning paper

1

With the aperture of the enlarger wide open, adjust and focus the enlarger to create an area of light on the base board large enough to cover a 20 x 25cm (8 x 10in) sheet of paper. With the red safe light filter in position, place the photographic paper emulsion (shiny) side up within the light area. Make sure all boxes of photographic paper are sealed and light tight – or kept well away from the enlarger until the red safety filter is over the lens.

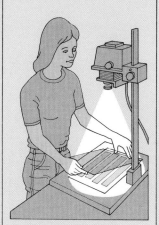

Positioning negatives and glass on the paper

2

Place the negatives, cut up into convenient strips, emulsion side (in this case, dull) down on the photographic paper. Gently lower the glass onto the negatives. This will hold the negatives in contact with the paper while allowing the light to pass through.

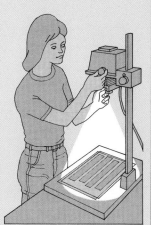

Exposing for a contact print

3

Set the aperture of the enlarger lens to *f* stop 8 or 11 and expose for approximately 10 seconds by flipping back the red safety filter. Accurate exposure times depend on the density of the negative and the aperture of the enlarger. You will get to know what time to give your exposures after you have gained a little experience of making them.

DEVELOPING 3
SAFE LIGHT ON

Mix the developing solution to 20° C (68° F). Remove the paper from the frame and place it in the developer, holding it by the edges and making sure that it is fully immersed quickly. Rock the dish gently to keep a constant flow of fresh developer moving over the print. The image should begin to appear in about one minute. Lift the print out of the solution occasionally to check for complete development. This will be when the blacks reach a true black and there is a good tonal range in the greys. Remove the print from the developer, let the remaining fluid run off the surface and place the print in water for 15-30 seconds agitating all the time. Remove from the water and place in the fixer.

DEVELOPING 4
ROOM LIGHT ON

Allow the print to fix for 10 minutes, then turn on the light and inspect the print. When the print is fixed, place it in running water and wash for 30 to 60 minutes. Remove from the water, sponge off the surface water and lay on a clean surface to dry.

How to make enlargements

With the help of your contact sheet, you can decide which negatives are worth enlarging and how best to frame them during printing. There may be unwanted areas on the negative which can be cropped out when printing. A special easel, with adjustable masking strips, will be very useful in this part of the process.

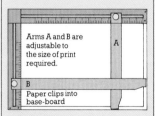

Arms A and B are adjustable to the size of print required. **A**

B Paper clips into base-board

Printing easel

This consists of a base-board on which to secure the paper, and adjustable arms or masking strips which can be moved to make a frame of variable size. With this you can visualise your final print.

PREPARATION ROOM LIGHTS ON 1

Assemble your printing equipment and lay it out in the most convenient places. You will require the equipment that was used for contact printing, but with the addition of a printing easel.

> DEVELOPING DISH
> STOP BATH DISH
> FIXING DISH
> CHEMICALS AT 20° C (68° F)
> PHOTOGRAPHIC PAPER
> PRINTING EASEL
> CARD FOR MASKING TEST STRIP
> BLOTTER PAD FOR DRYING PRINT
> SINK OR DISH FOR WASHING

Clean selected negative
Use a special blower brush or a soft cloth to remove dirt.

Position negative
Place the negative in a carrying frame and put the frame into the enlarger. Set the aperture wide open.

PRINTING SAFE LIGHT ON 2

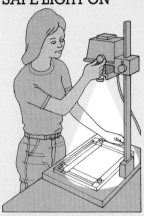

Enlarging
Turn on enlarger. Adjust the printing easel to the required print size. Adjust and focus the enlarged image to the required cropping and magnification using the printing easel. Set the aperture to f8 or f11 and switch off the enlarger – or place the red safety filter over the lens.

Choosing printing paper

At this point you should have decided on the grade of paper you will use. Grade 2 is for normal contrast negatives, grade 3 for lower contrast, and so on – up to 6 for negatives which are very grey or dense.

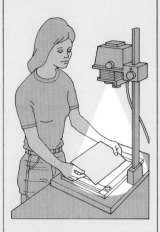

Make a test print

Before making your final print, print a test strip to establish the correct exposure time for that negative. Place a piece of printing paper in the printing frame – making sure that it covers the areas of maximum contrast. Take a sheet of black card and place it over the paper leaving 2.5cm (1in) uncovered. Expose for 10 seconds. Move the card to uncover another 2.5cm (1in) and expose for another 10 seconds. Repeat this procedure until all the paper has been exposed. Turn off the enlarger and develop and print as described for contact printing.

40 secs

30 secs

20 secs

10 secs

The test strip
The different exposures across the sheet will look like this.

Making the final print

Using the test strip, decide which is the best exposure time to use and whether you are using the best grade of paper. Place a fresh sheet of paper under the enlarger and expose for the chosen time. Develop and fix as before.

> **CAUTION**
> WHEN YOU ARE PRINTING MAKE SURE THAT YOUR BOX OF PAPER IS ALWAYS COMPLETELY CLOSED BEFORE TURNING ON ROOM LIGHTS.

DEVELOPING PROCEDURE

- Lay out your developing dishes in order from left to right: developer, stop bath, fixer. Make sure the dishes contain sufficient liquid to cover the print adequately. Remember, the chemicals should be at a constant temperature of 20° C (68° F).
- Develop the print until the dark areas are a true black. This takes approximately 1½ minutes.
- Transfer the print to the stop bath and agitate for 15-30 seconds.
- Transfer the print to the fix bath and let it fix for 5 minutes before turning on the room light. You can now inspect the print, but let it remain in the fixer for a further 10 minutes.
- Wash the prints in running water: 1 hour for single weight papers, 2 hours for double weight. Thorough washing prevents later discolouration.

Drying prints

Sponge off excess water and put the print face-up in a book of photographic blotting paper. Prints take several hours to dry.

Presentation

Photography does not end with the developing and printing of pictures. One of the photographer's biggest problems is how to show his pictures. The presentation of prints or transparencies can greatly affect the way the viewer sees the picture. Remember that photo albums are like picture books and, just as the book designer varies the size and quantity of pictures per page, you should avoid repetition and dullness in your own arrangement. Flat mementos, such as travel tickets, may help to add interest.

Slides should be arranged to lead the viewer through a sequence – just as a film or television show. Vary the pictures from long view to close-up and avoid the temptation to show too much.

Mounting prints

Mounting photographic prints onto board will strengthen them and make them more durable. Do not use ordinary household adhesives for this job – they may warp or colour the print. Rubber cements or the aerosol adhesives used in studios give the best results.

● **Rubber cement method**
Coat the back of the print and the mounting board with the rubber solution. Allow both surfaces to dry and then bring them together – starting at one edge and smoothing out air bubbles as you work across the print. Trim square after mounting.

● **Aerosol spray method**
These adhesives, which are available from artists' suppliers, can be used instead of rubber cement. Spray the back of the print only.

HOW TO MAKE A SIMPLE FRAME

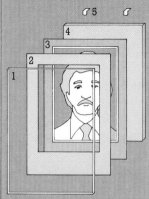

1 Glass or perspex to cover print.
2 Card or paper window mount.
3 Print on mounting board.
4 Backing board – 2cm (½in) chip board.
5 Mirror clips, or special frame clips, to hold everything together.

Make a frame to the appropriate size as shown above. The window mount is optional and could be left out. Use screw eyes and piano wire to make the hanging cord. A frame of this sort will ensure that your print will be well protected and attractively presented.

Glossary of terms

ASA
Film speed rating system developed by the *American Standards Association*.

Bi-concave lens
Lens with surfaces that curve toward the optical centre causing light rays to diverge.

Bi-convex lens
Lens with surfaces that curve away from the optical centre causing light rays to converge.

Bleed
The term used to describe the technique of printing a picture to the edge of the page – thereby having no border.

Bromide paper
The usual form of photographic paper for black and white images. It is coated with silver bromide.

Cable release
A flexible cable which can be used to operate the camera shutter. It is used mainly for long exposures

Density
This refers to the amount of silver deposit which occurs during exposure and development. It is a measurement of opacity.

DIN
Film speed rating system devised by the *Deutsche Industrie Norm* (German standards organisation).

Infra red
Light rays that occur beyond the red end of the spectrum. They are invisible to the human eye.

Newton's rings
Rings of coloured light produced by partial contact between two transparent surfaces.

Pentaprism
A five-sided glass prism which makes it possible to view the image on the focusing screen the right way round.

Polarisation
The restriction of the vibrations of light to one plane only. This is achieved by a filter which absorbs polarised light and reduces reflection from the surface of objects in view.

Ultra-violet
Light which falls at the lower end of the electro-magnetic spectrum and is invisible to the human eye. It causes *aerial perspective* (an effect of atmospheric haze), but this can be reduced by an ultra-violet filter.

Index

94

Index

Acknowledgments

The 'How To' Book of Photography –
Picture Taking and Making was created
by Simon Jennings and Company Limited.
We are grateful to the following
individuals and organisations for
their assistance in the making
of this book:

Cooper-Bridgeman Library: *photographs page 7 tl & tr*
Brian Craiker: *line and tone illustrations*
Ann Hall: *compilation of index*
Keith Johnson Photographic Ltd.,
Ramillies Street, London W1: *for the loan of equipment*
Lynda Poley: *picture research*
Science Museum, London *pictures pages 6; 7 b & tl*
Helena Zakrsewska-Rucinska: *hand tinting of engraving page 6*

Photography
All photography by the author,
with the exception of:
Caroline Courtney: page **81** *bl*
John Couzins: cover, title page and pages **32/3**
Gerry Cranham: page **15** *t*
Rose Jennings: page **II** *cr;* **18/19** *tc*
Van Withney-Johnson: pages **10** *t & b;* **II** *cl, tr;* **15** *br;*
18 *tl, bl;* **19** *tr, cr, br;* **23** *bl;* **26** *b;* **27; 30** *tl, cl, bl*
51 *bl, br;* **77** *br;* **81** *br*
Mark Woodham: pages **50** *bl;* **51** *tl;* **53** *bl;* **61** *br;* **63** *tr, b;*
64/5 *t;* **64** *b;* **68** *t;* **71** *t;* **76; 77** all except *br;* **81** *t, bc, br*
Abbreviations: *t* top; *b* bottom; *tl* top left; *tr* top right;
cl centre left; *cr* centre right; *bl* bottom left; *br* bottom right;
tc top centre; *bc* bottom centre; *l* left; *r* right
All photographic prints made by David Strickland and Mark Woodham.

Typesetting by Text Filmsetters Ltd., Orpington, Kent
Headline setting by Diagraphic Typesetting Ltd., London
Additional display setting by Facet Photosetting, London

Special thanks to Norman Ruffell and
the staff of Swaingrove Ltd., Bury St. Edmunds,
Suffolk, for the lithographic reproduction.